Lucian Freud *works on paper*

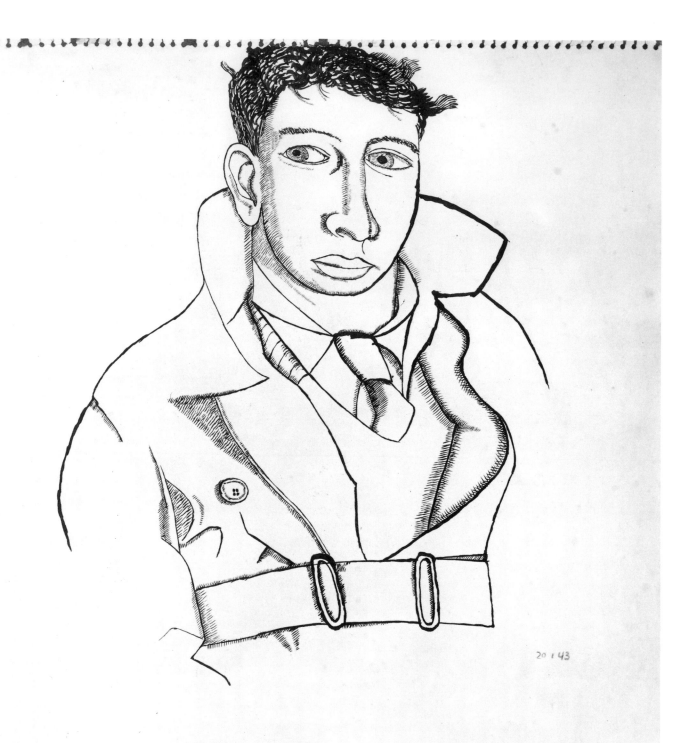

20 I 43

Lucian Freud
works on paper

116 illustrations, 39 in color and 32 in duotone

Thames and Hudson

Text © 1988 The South Bank Board and the authors
Illustrations © 1988 The Artist

First published in the United States in 1988 by
Thames and Hudson Inc., 500 Fifth Avenue,
New York, New York 10110

Library of Congress Catalog Card Number 87–51288

Designed by Derek Birdsall RDI

Printed and bound in Great Britain

Contents

Nicholas Penny

The Early Works 1938–1954

Lucian Freud entered the Central School of Arts and Crafts in 1938, aged fifteen, and took, at his father's insistence, the general course. The one field in which he did not receive instruction was drawing which was taught there at that period by William Roberts and Bernard Meninsky. Drawing, however, was what Freud was then chiefly engaged in – although he was also spending a lot of time showing off in Bohemia, where he already enjoyed a reputation as a prodigy. When asked what he was working on, he would invent pictures. He wanted to be a painter, but was aware that he had not started. This changed when, in the early summer of 1939, still not seventeen, he enrolled at the East Anglian School of Drawing and Painting which had opened two years earlier at Dedham in Essex.

Suddenly Freud found that he could paint. For a while he produced a painting by day and a painting by night. He drew too; but not as a preparation for painting. In fact, none of the drawings in this exhibition were made *for* paintings, although many may be related to paintings and some of the more recent have arisen from them. Some of them are sketches but many are images quite as finished, quite as much 'pictures' as his paintings – which is one justification for this exhibition.

Freud emerges, perhaps in consequence of ruthless self-censorship, as a confident, mature artist when still a teenager, and there seems little point in trying to detect formative influences. Looking at some of his early drawings, Freud mentioned to me his debt to Beardsley's work, specifically the Lysistrata illustrations. Who could have guessed at this? Perhaps it helps to

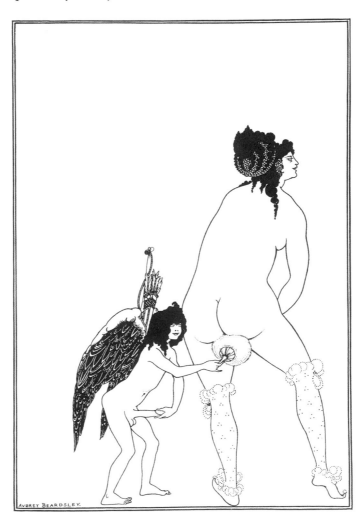

Aubrey Beardsley
'The Toilet of Lampito', 1896
from *The Lysistrata of Aristophanes*
(London 1896)

explain the explicit eroticism, as well as the linear economy, of *Boy on a bed*. When I first saw this drawing, however, I was struck by the way that the toes were represented as a row of circles. It reminded me of certain mannerisms in the drawings of Edward Burra, who also liked to outline, emphatically, the lips. If the sources of Freud's art are elusive, comparisons may, all the same, be valuable. It is worth bearing in mind, for instance, when looking at *Boy with a pipe* or *Boy with a pigeon*, not only Ingres's drawings, which Freud greatly admired, but the use that Picasso had already made of them, as in his *Portrait of Erik Satie*.

Freud owed much to Cedric Morris, the principal and co-founder (with Lett Haines) of the East Anglian School of Drawing and Painting, but he was not in any orthodox sense taught by him. Freud observed that Morris hardly ever talked 'to' him, but reminisced, often about other artists. 'Much of what he said was maddening', he adds, not without affection. Morris's subject-matter was Freud's as well: portraits; views from a window, sometimes oddly coalesced with a foreground still-life; plants, still-lives composed of disparate, personally significant, objects. Speaking of Morris's art, Freud reveals what he admires in it but also, no less significantly, what he has always tried to avoid and what he perhaps reacted against.

Freud does not like some of Morris's 'pseudo-wild', profuse but decorative still-lives, which he likens to Chinese wallpaper, nor those in which, as he puts it, 'everything rhymes'. 'Artfulness' is a disparaging term favoured by Freud. Also, he prefers art to disturb rather than to please in any easy way. To him, every work of art should be a challenge to the artist (he quotes Yeats on the 'fascination of what is difficult'), which for Cedric Morris it was not, at least not always.

What Freud chiefly admired, and still admires, in Morris's work is the portraiture. This amused Morris because most people loathed it – no doubt they did so on account of its 'alarming candour', a quality which Freud has pursued with consistent success in his paintings of people. The phrase comes from Eric Newton's review in *The Sunday Times* of Morris's exhibition of portraits at the Guggenheim-Jeune Gallery in Cork Street in 1938, which Freud could have seen but didn't (his acquaintance with the portraits coming from the fact that at Dedham he liked to work by himself and used a stable in which the portraits were stored).

Morris's double portrait of David Carr and his future wife Barbara Gilligan, fellow students with Freud at school, is a good example of Morris's work up to the 1940s at its toughest. Carr's face is memorable for its fierce concentration and the separate treatment (and relative enlargement) of each organ of sense. This is something which one finds also in faces drawn by Freud in the early 1940s. There is also something ferociously final about the artistic re-assembly of ears, eyes, nose and mouth, and a sense of explosive inner life in Morris's best portraits, as well as in these early ones by Freud.

Freud has pointed out to me how Morris didn't include the hands in his portraits, admitting that in the case of the painting of the Carrs the image may have gained something in 'totemic power' as a consequence. He remembers asking Morris why this was. The reply that the hands 'meant too much' to him Freud found unsatisfactory. After all, he reflected, what is better than trying to depict what means too much to you?

In Freud's own portraits the hands are extremely important and in one case, *Man with folded hands*, they seem to epitomize the rest of the drawing. Often enough one hand is missing or partially concealed – which, however, hardly diminishes our awareness of it. What is not included in Freud's drawings is often of crucial importance. Of those exhibited here only one,

Head of a woman, could be said to be unfinished, but in almost all of them there are lines which stop, or for which we look in vain. Much, after great deliberation, has been excluded.

It is often the setting and even the support which is absent. Upon what does the man with folded hands repose? Out of what do the plants grow? What is not included can contribute to make the image puzzling – something to piece together as we look at it. Limbs are not always easy to locate. Particular difficulties in drawing, for instance, the foreshortened upper legs of seated men, are exhibited. Folds and swelling of clothing are by no means easy to 'read' – the upper left-hand side of the *Boy in bed with fruit* or the lower part of the *Boy with a pigeon* are good examples of this.

Arms in Freud's drawings have a tendency to separate themselves. We seem invited to consider the figure without them. (The horse, we recall, which Freud carved at art school and which secured his entry to the Central School had only three legs.) In some cases this quality in the drawings may be related to Freud's preference for studying the figure from several points: he explained that the striking discord between one side and the other of *Girl holding her head* was due to this, and so too surely is the puzzling shape of Juliet Moore's cradle. He also felt drawn to the dislocation of limbs in dolls or dummies, as in the attitude of the teddy bear which stays awake whilst its owner sleeps, or the prance of the pantomine horse on the boulders (in the only lithograph Freud has made).

Pablo Picasso
Portrait of Erik Satie, 1920
pencil, 62.3 × 48 cm
Musée Picasso, Paris
© DACS 1988

Cedric Morris
Portrait of David Carr and Barbara Gilligan
oil on canvas, 100.3 × 74.6 cm
Trustees of the Tate Gallery, London

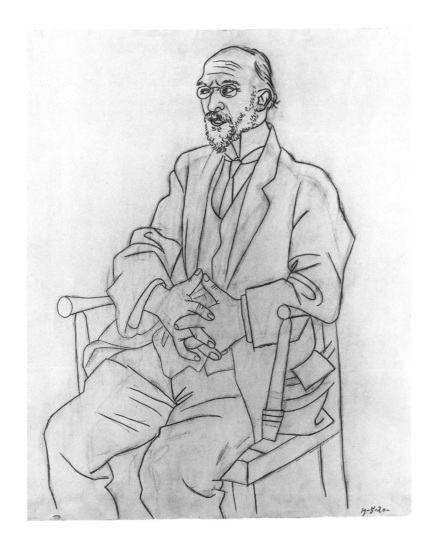

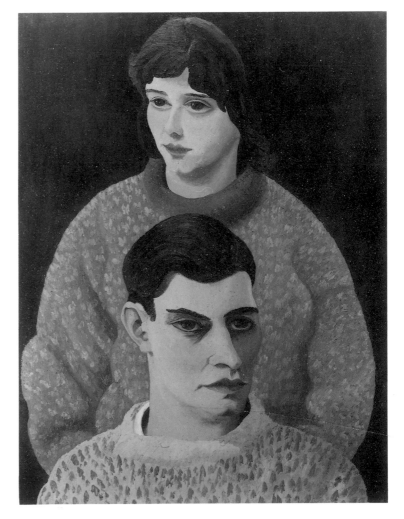

What makes the drawings of the early 1940s to which I have referred most remarkable is the tension in them between Freud's extreme sophistication, the cunning and wit of his line, and his determination to present, often with bluntness and force, images with all their essential idiosyncracy intact. The grotesque is considered preferable to an easy elegance. Freud speaks with keen admiration for the early drawings of peasants by Van Gogh, as well as for the work of Ingres.

Having burnt down the East Anglian School in the summer of 1939 by smoking at night with David Carr, Freud resolved to go to sea. He managed, through a friend's father, to get a pass into the Liverpool docks and then to obtain a Merchant Navy ID card by pretending to have lost one when a boat had been torpedoed. The drawings of the fellow crew members of the boat he sailed on were made in an ordinary Winsor and Newton pad, the oil colour in some of them applied with his fingers. The line has a nervous, almost tremulous quality, found also in some of the portraits Freud made in a publisher's dummy presented to him by his friend Stephen Spender in December 1939. Such drawings are hard to compare with more calculated works, such as *Boy in bed with fruit* for example, which was in fact conceived as an illustration for poems by Nicholas Moore (a son of the philosopher G. E. Moore), or the haunting self-portrait of 1943, with its carefully shaped areas of shading composed of miniature pencil strokes and its delicate and subtle colouring in crayon (one yellow for part of the pillow, another for the area above; blue for the eyes and part of the face). The medium with

Stephen Spender, 1940
pen and ink with wash, 21.3 × 14.6 cm
Private collection

Horses, 1940
pen and ink, 21.3 × 14.6 cm
Private collection

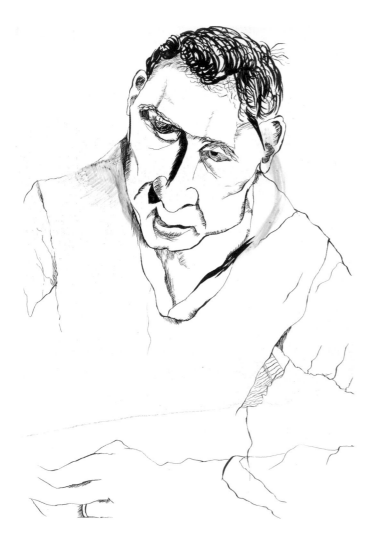

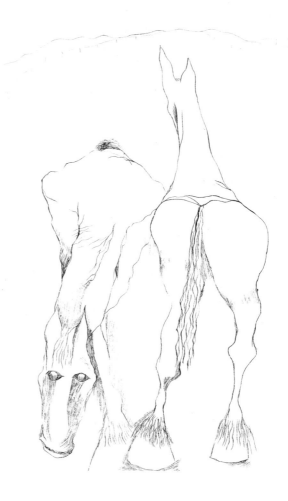

which these drawings were made also varies. Some were made in pen, others in pencil and crayon, and *Man in a leather coat*, which might in reproduction be mistaken for a pen drawing, was made with the point of a brush. Nevertheless, we may say with some confidence that Freud's work was increasing in tightness of line, and in tension generally, in these years.

The plants Freud chose to draw in 1943 and 1944 – gorse and thistle, sea-holly and cactus – are stiff and prickly things which one hesitates to touch, and this suits the sharp linear style and the precarious, even nervous, and occasionally menacing atmosphere it communicates. The cacti, however, are charming. And there is nothing spuriously eerie or calculatedly chilling in the Surrealist manner about Freud's imagery. Freud was interested in Surrealism but he prefers, as he puts it, to depict the unlikely rather than the unreal. A beautiful example of this is the drawing of a pair of horses facing opposite ways and foreshortened, in the dummy sketchbook already mentioned. There are also fantastic drawings in this book, some of them involving horses and fishes like those in Freud's lithograph *Horse on a beach*, but they are less startling images than this one. Freud can discover something strange in, or about, things as mundane as a pillow, a paper bag, or a chelsea bun.

Freud never lost touch with Cedric Morris. On leaving hospital, after returning ill from his adventures at sea, he resumed work at the school which had now moved to Benton End. When he moved to London he occasionally returned to stay. It was on one such occasion, a weekend in 1943, that he drew these cacti and the stuffed bird. It was part of an arrangement of

Vincent Van Gogh
La Crau, seen from Montmajour 1888
reed pen
Vincent Van Gogh Foundation/National
Museum Vincent Van Gogh, Amsterdam

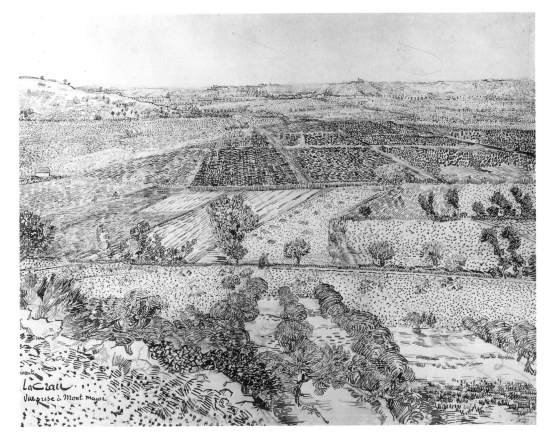

objects which Morris, who was a keen gardener, had made on the window-sill of his studio (it was not, incidentally, as has been implied elsewhere, assembled as a composition for one of Morris's own still-lives).

A charming footnote to the Tate Gallery's Cedric Morris exhibition catalogue by Richard Morphet reads 'Cedric started at the top and Lucian Freud in the middle.' This applies to Freud's procedure in his drawings as well as in his paintings. It presupposes the rejection of pre-ordained composition and makes coherent spatial 'logic' nearly impossible. It makes difficulties – what Freud calls, with enthusiasm, 'balancing tricks' – near the edges inevitable. The artist's progress is one the beholder in some measure re-enacts.

Of *Cacti and stuffed bird's* subject Freud remarked to me 'you can see it goes on and on'. You can see this also in another *tour de force* of the same year, the view of Loch Ness from Drumnadrochit, a drawing completed over about a week from a hotel window. As Freud intended, it 'leaves the eye wanting to see more'. The unexpected distribution of the artist's scrutiny across the view and into it, discerning vital, eccentric life in inanimate and organic items alike (and only a little uneasy with the clouds); the cropping at the edges, and the often contiguous areas of calligraphic patterning – all this may be found also in Van Gogh's landscape drawings (cited by Freud himself when discussing this drawing with me), although those were made with a reed and this with a tiny mapping nib. The merit of this drawing (and, Freud suspects, its Scottish subject) attracted Mr MacDonald of the Lefevre Gallery

Albrecht Dürer
Portrait of Willibald Pirckheimer, 1524
Visitors of the Ashmolean Museum, Oxford

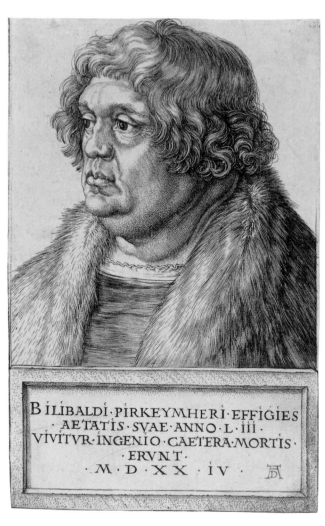

who gave Freud his first exhibition in the following year, 1944. Freud made only one other comparable drawing – a view in Dorset, now untraced.

The same calligraphic patterns in this drawing – hatching, cross-hatching, densely clustered curls and dashes – are found in Freud's studies of the varied feathers and scaly legs of dead birds of the same period. The birds may be dead but the forms possess the same organic vitality that Graham Sutherland found in twisted roots and thorn branches. The use of colour is similar to Sutherland's (and very different from the delicate heightening of the *Cacti and stuffed bird*) and so is the energy of the penwork. In the earliest of these, *Dead bird*, unusually, instead of an intriguing emptiness of paper, Freud has provided an equally space-cancelling green wash (it was concocted out of a pigment which Freud found in a bargees' colour shop in Paddington).

During the later 1940s Freud's penwork becomes neater and finer, although a rapid sketch of 1947 shows that the draughtsman of the early 1940s had survived. In the unusually large self-portrait *Man at night*, of 1947/48, the areas of shade are achieved by means of meticulously and apparently methodically spaced stipple, reminiscent of certain quasi-mechanical printmaking methods. It is associated with an interest in texture (hair, fur, fibre, wool) comparable to Dürer's but also with a new interest in lighting, a dramatic artificial (somewhat stagey) side-light here, a softer, caressing light elsewhere and also by 1950 subtle nocturnal light and mysterious effects of *contre-jour*.

'A walk to the office'
from *The Equilibriad*, opposite p. 16
(Hogarth Press, London 1948)

'Street scene'
from *The Equilibriad*, opposite p. 26
(Hogarth Press, London 1948)

Girl in a white dress, 1947
conté, crayon and pastel on buff paper,
47 × 48 cm
Mrs Pamela Wynn

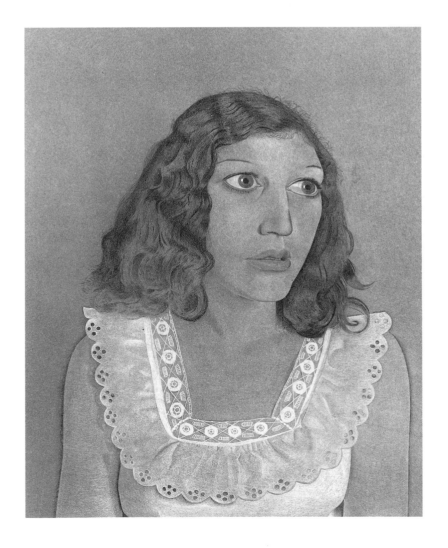

It is in this period also that Freud's drawings – and some of his paintings – seem to depict a tense situation in a plot frustratingly unknown to us. It is surely not coincidental that he was also working as an illustrator: some of the drawings he made for *The Equilibriad* by William Sansom, published in a limited edition by the Hogarth Press in 1948, reveal the suspense with which he endowed images of this sort, a suspense in excess of what one expects from the text. The most ambitious of Freud's etchings, *Ill in Paris*, possesses this quality, as much as the drawings *Man at night* or *Interior scene*. It was in France that Freud first experimented with this medium, to the basics of which he had been introduced by Graham Sutherland. The acid was obtained from local pharmacists; the hotel room basin served as a bath. The fine lines and small flecks of the etching needle relate closely to the quality of his drawings and Freud at this stage thought of etching as an extension of drawing.

In the extraordinary portrait drawing of Christian Bérard (made in Paris in the winter of 1948 at the suggestion of the sitter, who had met Freud earlier in the year when he was working at Covent Garden – thus the nearest thing to a commissioned portrait among these drawings), the technical finesse is such that it is impossible to tell in reproduction what comes from the stroke of the black and white conté chalks and what from the texture of the paper. The same is true of one of the conté, crayon and pastel drawings, *Woman in a white dress* of 1947. The miniature working invites close examination and generates (independently of any descriptive effect) a nervous excitement. There is, as it were, electricity in the air.

The *Dead monkey* of 1950, like the portrait of Bérard of 1948, represents something new in Freud's work, but we are not unprepared for either drawing. We have already seen drawings of heads against pillows against nothing, and seen dead animals and stiff furry creatures from surprising angles. When we look at *Girl's head* of 1954 we are also startled by its novelty. It has a new lyricism which is consequent upon relaxation, but not loss of energy – upon a freedom of execution which reflects an awareness of the freedom of the body represented. Of course it can be related to earlier drawings – in presentation to the *Girl holding her head* and in other respects to the *Drawing from Flyda*. All the same, the leap is now a larger one.

This, *Dead monkey* and an interior scene are the only drawings from the 1950s included in the exhibition. During this decade Freud's art was changing radically, and not at all in deference to popular or 'advanced' taste. His exhibition at the Marlborough Gallery in 1958 was badly received by almost everyone. He had ceased to be fashionable. Kenneth Clark, who had formerly done much to support and encourage him, informed him that he 'admired his courage' – and never spoke to him again. The change entailed the abandoning of drawing which, Freud felt, had kept his painting too linear.

On his canvases Freud began to make preliminary drawings in charcoal. Equivalent lines in pencil appear below the watercolour washes, dashed down and allowed to run, in the drawings of faces and bodies, reminiscent of Rodin's, which Freud made when on holiday in a hotel in Greece with his children in 1961. These lines are mere indicators, they do not define these carnal spectres. The artist who had once feared that he would not be able to control paint is here daring to experiment with losing control. It is hard to think of another artist who turned his back on so much.

Robert Flynn Johnson

The Later Works 1961–1987

'How alike are the groans of love
to those of the dying'
(Malcolm Lowry *Under the Volcano*).

The art of Lucian Freud possesses a power to involve the viewer intensely, almost to the point of intrusion, in aspects of the artist's life on which he has levelled his severe artistic scrutiny. According to Emile Zola, 'A work of art is a corner of creation seen through a temperament.'[1] Freud's 'corner of creation' is his everyday environment and the people he knows. He has stated: 'My work is purely autobiographical. It is about myself and my surroundings. It is an attempt at a record. I work from the people that interest me and that I care about, in rooms that I live in and know. I use the people to invent my pictures with, and I can work more freely when they are there.'[2] His art contains arresting images which tell a world of truth through a pose, a gesture or an expression.

More than any other twentieth-century artist, Lucian Freud makes us acutely aware of existing as human beings; of our sexuality, of being fat or thin, of getting old, of being mortal. Other artists have touched on this theme but without Freud's consistency. Edvard Munch created powerful images, yet their extreme emotional uniformity touches on only a small aspect of human experience. In his poignant Blue and Rose periods, Picasso alternated between introspection and sympathy for the downtrodden. Expressionistic artists, including Georges Rouault, Egon Schiele, Käthe Kollwitz and Chaim Soutine, were more involved with the depiction of severe emotional distress than in coping with the act of living day to day. Curiously, it is the American artist Edward Hopper whose art can most readily be compared to Freud's in its exploration of daily existence. Hopper does this not through the figure but through the depiction of environments and the human interaction that takes place within them. It is not surprising that Freud was impressed with the major Hopper retrospective at the Hayward Gallery in London, in 1981. Hopper carried in his wallet a quotation from Goethe which could apply as much to Lucian Freud's art as to his own: 'The beginning and end of

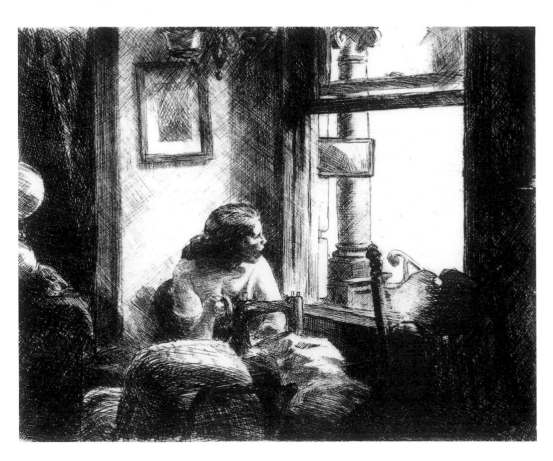

Edward Hopper
East side interior, 1922
etching, Z. 8, 20.3 × 25.4 cm
The Fine Arts Museums of San Francisco
Achenbach Foundation for Graphic Arts
1964.141.42

all literary activity is the reproduction of the world that surrounds me by means of the world that is in me, all things being grasped, related, re-created, moulded, and reconstructed in a personal form and an original manner.'[3]

Freud has been described as difficult, both as an individual and as an artist. Forsaking the social and political manoeuvering of the art world for his studio, Freud has maintained an aloof yet proud independence over the years. 'To be aristocratic in art one must avoid polite society', George Moore wrote in the nineteenth century.[4]

Freud's art contains drama without narrative. Except for occasional known individuals (his father, mother, children, or well-known people such as the painter Francis Bacon), the identities of his subjects are not divulged, nor does the artist consider such information important. Insight into Freud's art is gained by scrutiny of the work itself. All his art is autobiographical in nature, but the works are wrapped in a self-imposed silence. This allows the picture itself, not the circumstances surrounding its creation, to reign.

The art of Lucian Freud is based on the assumption that, even at the end of the twentieth century, significant art can come from the acute observation of ordinary events in one's daily life. How simple, yet how profound such a conclusion is. Freud feels most comfortable in direct contact with his subject-matter. 'I am never inhibited by working from life. On the contrary, I feel more free; and I can take liberties which the tyranny of memory would not allow. I would wish my art to appear factual, not literal.'[5] Freud's ideas are compatible with Courbet's statement in 1861: 'Imagination in art consists of finding the most complete expression for an existing thing but never in imagining or creating the object itself.'[6]

There is no question that the feeling of unease, which many feel when viewing (or being confronted by) a work of Freud's, is the recognition of the factual and emotional correctness of what they see and feel in his art. This ability to create a sense of *déjà vu*, to link his reality to our own, is an extraordinary achievement.

T. S. Eliot wrote of modern society: 'The majority of people live below the level of belief or doubt. It takes application and a kind of genius to believe anything and to believe anything will probably become more and more difficult as time goes on.'[7] The power of Freud's art lies in its ability to make us believe and to feel. That Freud's humanism is in opposition to much of today's undisciplined, nihilistic, media-conscious art, is to be expected. However, to those with perception and a belief in the power of art to transcend mere surface effects, the art of Lucian Freud will never be out of fashion.

By the end of 1954 a curious turn of events occurred in Lucian Freud's career. He ceased drawing. For the next seven years drawing as an independent activity was absent from his art. Freud's earlier work was always based on a strong linear component. John Russell wrote of this work: 'Drawing continually, as he did, he gradually became aware that he used drawing as a means of keeping painting at bay. Feeling the difficulty of painting most acutely – to the point at which he was barely able to get the paint to cohere at all – he was also aware of its superior potency. Paint was for later.'[8] For Freud, drawing was the structure on which his subject-matter was built. However, by the early 1950s Freud was becoming discontented, despite the fact that, as Lawrence Gowing wrote, 'Freud's achievement at thirty convinced everyone but himself.'[9] At that time Freud turned away from drawing to concentrate on a new manner of painting that was rougher, more sensual and painterly than the enamel-like, precise surfaces of his earlier work. As Freud later observed, 'You long to do something that doesn't look like your own work – something that frees you from your own nature.'[10]

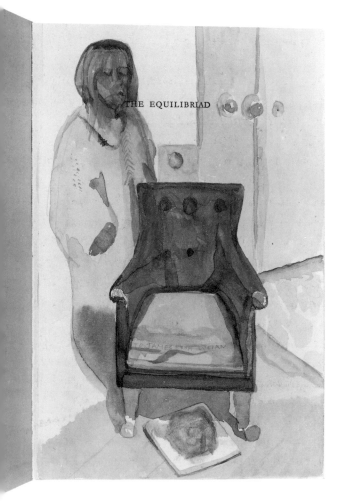

Woman in an interior, c. 1966
watercolour and pencil, 22.4 × 14 cm
Private collection, courtesy
James Kirkman, London

Like his friend Francis Bacon, who has never drawn as a separate artistic activity, Freud continued to draw, but only within the context of creating a painting. After a disquieting period of evolution, his new style of painting achieved a level of confidence and originality which Freud has maintained to the present day.

It was only in 1961 that he began to draw again. On a trip to Greece with his children, Freud took with him watercolours, a medium which he had not explored before. The resulting images were completely unlike his drawings seven years earlier. Heads and crouching or extended bodies were depicted in subtle tones of green, tan and umber. Loose, painterly, abstracted washes replaced earlier incisive linearity, and monumentality and form took the place of characterization and detail. These watercolours remain Freud's most abstruse works on paper.

Drawing was to remain a minor activity until 1970. Occasionally Freud continued to explore the watercolour medium with such works as the carefully modelled *Woman in an interior*, 1966. He drew this work on the title page of a novel, *The Equilibriad* by William Sansom, for which he did the illustrations in 1948.

Another work from this period is the enigmatic pen and ink drawing of 1968, *I miss you*. Inscriptions are rare in Freud's oeuvre. This one is as much a message as a title. The scene is a loose but expressively drawn bathroom in a state of complete disarray. Was this an expression of the physical and emotional distress of the artist at someone's absence? Whatever the motive, the emotion is conveyed. It is interesting to note the similarity of this work to one of 1949, nineteen years earlier, *Mother and baby*, which depicts his wife and first child. It appears that Freud's precision as a draughtsman dissolved when confronted with the highly personal circumstances of these subjects. A nearly calligraphic manner temporarily replaced his usual style.

Portraiture has always been the major focus of Freud's art. With few exceptions, it has formed the main body of the artist's drawings and prints since 1970. Freud usually depicts his subject alone and not in the context of another person or object. Although this isolation heightens the concentration on the subject, it also does not allow any visual details to augment the context of the work. Manet commented on this type of portraiture: 'You would hardly believe how difficult it is to place a figure alone on a canvas, and to concentrate all the interest on this single and unique figure and still keep it living and real. To paint two figures which get their interest from the duality of the two personalities is child's play by comparison.'[11]

Freud usually confronts his subjects in a bold, frontal manner, which creates scant distance between the viewer and the image. The portraits are almost always quite small ('lifesize looks mean', Freud once commented).[12] He concentrates on the face, often excluding the shoulders. This bold manner of portraiture is not without historical precedent. Northern Renaissance artists, such as Hans Holbein, Albrecht Dürer, and Hans Baldung Grien, employed this technique with great success. In more recent times artists as diverse as the great German nineteenth-century draughtsman Adolf von Menzel, and the obsessive twentieth-century English artist Stanley Spencer, have used such a manner of characterization. The frontality in Freud's portraiture allows us to study these faces more closely than we would ever comfortably do in real life. Like viewing people through a one-way mirror, we can be both intimate and safe.

In these portraits, Freud is not rendering physiognomy so much as establishing the character of his subjects. He has said: 'I know my idea of portraiture came from dissatisfaction with

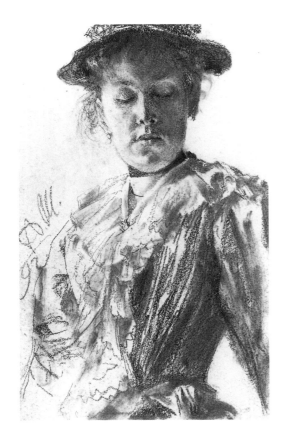

Adolf von Menzel
Portrait of a woman, 1892
graphite with stumping, 18.2 × 11.5 cm
Private collection

portraits that resembled people. I would wish my portraits to be of the people, not like them.'[13] Viewpoint is a crucial element in most of Freud's compositions. He is not afraid to assume a low vantage point, such as in *Head and shoulders of a girl*, 1979, or a high vantage point, as in *Ib*, 1983. 'I take readings', Freud has said, 'from a number of positions because I don't want to miss anything that could be of use to me.'[14] The diagonal placement of the head in a reclining position is a favourite pose, which Freud has used in numerous drawings such as *Head of a girl*, 1973, *Alice*, 1974, and *Annabel*, 1975, as well as in a number of his prints. The expressive use of arms to punctuate a pose is also noticeable in such drawings as *Francis Bacon*, c. 1970, *Alice*, 1974, and *Ib*, 1983.

The obvious emotional rapport that exists between Freud and his subjects is nowhere better illustrated than in the portraits of his parents. There are no paintings of his father, but a series of watercolours and drawings do exist. *The painter's father*, 1970, completed the year his father died, is a drawing of great sensitivity that attests to Freud's obvious love and respect. Of the portraits of his mother, Freud has written: 'I started working from my mother because of my father's death in 1970.'[15] This simple explanation underscores one of the most moving and penetrating series of portraits of this century.

Freud's prints and drawings of his mother show subtle shifts of attitude and mood, which are based on a lifetime of observation. It is through his mother's penetrating eyes – attentive, weary or quietly defiant – that Freud's drawings reach out to us. Sympathetic, yet unwavering

Sir Stanley Spencer
Sir Henry Slesser, P.C., c. 1920
graphite, 30.5 × 24.1 cm
Private collection

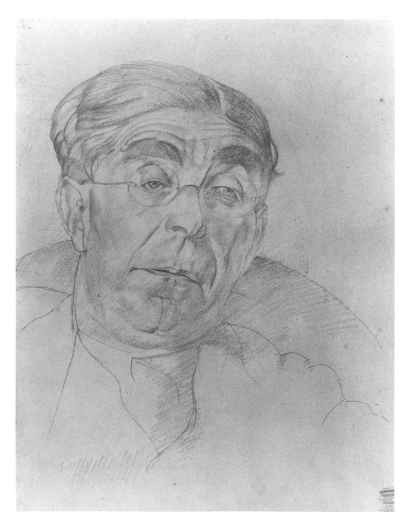

in their honesty, these are the most profound visual statements of the feelings of an artist for his mother since Rembrandt.

In 1982, at the time of Lawrence Gowing's superb monograph on Lucian Freud, it was suggested to the artist that he explore the possibility of making some etchings to accompany a de luxe edition of the book. The result was a series of fourteen portraits, Freud's first prints since his brilliant *Ill in Paris*, etched thirty-four years before. They are composed, not surprisingly, with a more relaxed line than his earlier etchings. They reflect a spontaneity and simplicity of execution rarely seen in the frequently oversophisticated world of contemporary printmaking. It is to earlier twentieth-century works, such as Käthe Kollwitz's self-portrait etchings, that one must look to find parallels with Freud's recent printmaking. Direct, frontal, almost confrontational, these etchings are similar to Freud's portrait drawings. There is, however, a greater starkness and severity, effected by the thin black masses of wiry lines that compose the faces.

Viewpoint and composition are, as always, a major concern to Freud in these prints. He often compresses the focus of his portraiture so much that the edge of the print intrudes on the head of his subject. The result is a more intense visual encounter. Examples of this are his 1982 etchings *Lawrence Gowing*, *Lawrence Gowing I*, *Head of a girl I*, *Head on a pillow*, *Fragment head*, the 1985 etching, *Head of Bruce Bernard* and the *Head of a man*, 1987. On one occasion, however, Freud achieved the same effect by altering a print in a later state. In *Head and shoulders*, 1982,

Rembrandt van Rijn
Rembrandt's mother with hand on chest, 1631
etching, Holl. 349 ii/ii, 9.4 × 6.6 cm
The Fine Arts Museums of San Francisco
Achenbach Foundation for Graphic Arts
The Bruno and Sadie Adriani Collection
1959.40.6

Freud took a completed etching in its first state, and severely cropped the top of the plate to transform the second and published state into a work of greater compositional force.

The atypical mood expressed in the 1982 etching *A couple* calls for comment. Except for a faint hint of amusement in the early painting *Woman in a multicoloured coat*, 1939, and the glimmer of a grin in *Woman smiling*, 1958/59, and the smile in *Naked child laughing*, 1963, there are few signs of levity in Freud's art before this print. The etching was based on a photo-booth snapshot of Freud and a companion. It is not surprising that Freud should rely on a photograph to depict laughter, since it would have been impossible for him to use his normal process of lengthy observations to catch such a fleeting emotion.

Lucian Freud does not paint or draw the nude. Instead, his subject-matter is emphatically the depiction of naked human beings. Freud has said: 'I get my ideas for pictures from watching people I want to work from moving about naked. I want to allow the nature of my model to affect the atmosphere, and to some degree the composition. I have watched behaviour change human forms.'[16] Freud focuses on the reality and vulnerability of the human body rather than any classical ideal of the nude. The beauty seen in his human forms is natural and unforced. His prints and drawings of the human body associate Freud with a long realist tradition, that includes such artists as Rembrandt in the seventeenth century, Edgar Degas in the nineteenth century and Otto Dix in the twentieth. Although Freud occasionally focuses on details of human anatomy, as in *Drawing for naked figure*, 1973, and *Two Fragments*, 1977, there is always a sense of quivering life within these works.

In 1985 Freud produced two ambitious etchings, *Girl holding her foot*, and *Blond girl*, which

Head and shoulders, 1982
etching (1st state, unpub'd), 30 × 30 cm
Private collection, courtesy
James Kirkman, London

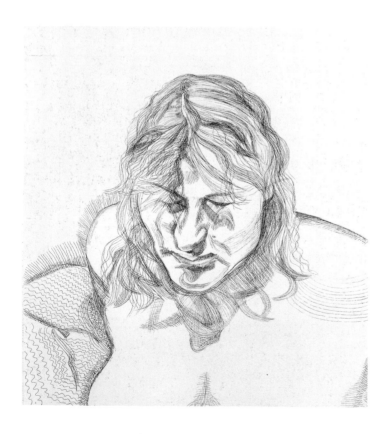

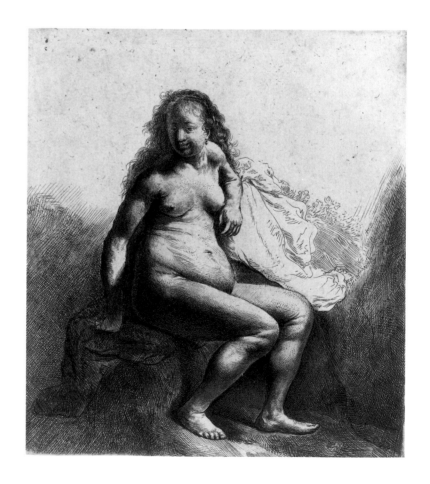

combine monumentality of scale with intimacy of pose. They are within the tradition of Degas's revolutionary 'keyhole' pastels of nudes, first exhibited in the final Impressionist group exhibition of 1886. Of these pastels, Paul Gauguin wrote: 'A fully clothed woman by Carolus-Duran is smutty. A nude by Degas is chaste. But his women wash in tubs! That is precisely the reason why they are clean. But you can see the bidet, the douche, the washbasin! Just the way it is at home.'[17] Like Degas, Freud's women have an unaffected demeanour about them. They are unashamed, yet strangely private. They are often erotic but always sexual.

The naked male body, seldom seen in twentieth-century art, is a subject from which Lucian Freud has not shied away. His two paintings, *Naked man with rat*, 1977/78, and *Naked man with his friend*, 1978/80, are major works in his oeuvre. *Man posing*, 1985, is the largest and most ambitious etching Freud has yet undertaken. The print displays unusually rich detail, from the overstuffed, torn sofa and the large frayed book, to the wood grain of the floor and the patterning on the wall. Nothing, however, distracts from the boldly straightforward pose of the naked man, who reclines with legs apart, and stares out at us with fatigue and resignation. Although the focal point of the composition is as much the man's genitalia as his expression, Freud has treated the figure without suggestion or titillation. If this etching shocks, it is through its honesty. In this century, only Egon Schiele dealt with the male body with the expressiveness that Freud has brought to this etching.

Rembrandt van Rijn
Naked woman sitting on mound, *c*. 1631
etching, Holl. 198 ii/ii, 17.5 × 16 cm
The Fine Arts Museums of San Francisco
Achenbach Foundation for Graphic Arts
Purchase 1967.22.9

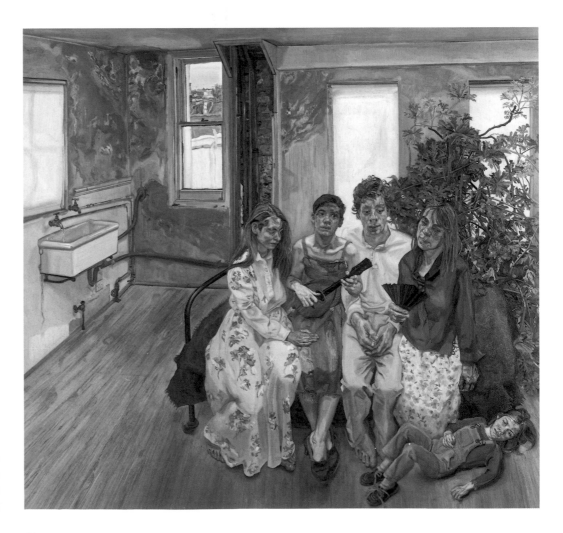

Large interior W.11 (after Watteau), 1981/83
oil on canvas, 186 × 198 cm
Private collection, courtesy
James Kirkman, London

J. M. W. Turner
Sun rising through vapour: fishermen cleaning and selling fish, 1807
oil on canvas, 134.6 × 179.1 cm
National Gallery, London

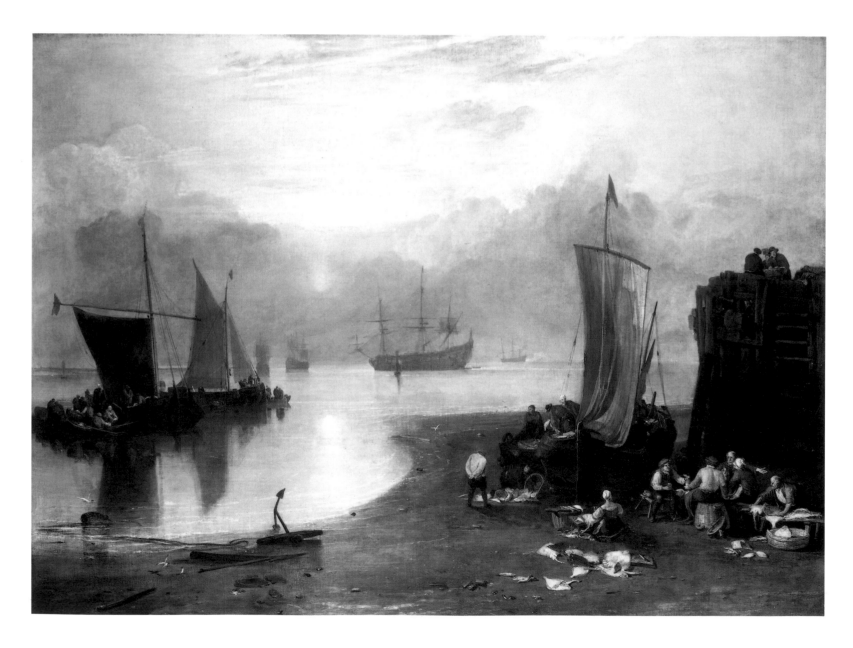

Animals, both live and inanimate, have interested Freud since his earliest artistic efforts. For example, he has always had a love of horses. During his time at Dartington Hall, a boarding school, Freud passed up art classes in order to ride. Works such as *A filly*, 1969, and *Head of Success*, 1983, are only two of many drawings where Freud has examined horses with all the feeling and thoughtfulness that he would expend on a human being. At times in his career Freud has paired a human and an animal to form curious dual portraits. Examples of this are paintings such as *Girl with a kitten*, 1947, *Girl with a white dog*, 1951/52, *Naked man with rat*, 1977/79, and *Double portrait*, 1985/86. A portrait drawing of this type is *Girl with a monkey*, 1978. The lethargy evident on the face of the reclining female figure contrasts with the animation of the energetic monkey that appears above her head. Freud is clearly interested in the unusual emotional dynamics of bringing man and animal together in works of art in such a way that the two are infused with equal amounts of character and individuality.

A major preoccupation between the years 1981 and 1983 was the completion of Freud's most ambitious painting, *Large interior W.11 (after Watteau)*. This important work was inspired by Antoine Watteau's *Pierrot Content*, c. 1712. Freud does not work from preliminary studies: instead, he draws his composition with charcoal directly on the canvas, effacing it as the painting proceeds. Freud executed a number of impressive drawings based on elements of this work, yet they were all done after the painting was completed. It is fascinating that Freud reverses the traditional artistic method of working from studies to a finished whole. He completes the work, and then takes fragments out of the composition to be used in drawings that stand alone as independent works of art.

In 1986, the National Gallery in London approached Lucian Freud to select works from their permanent collection that were meaningful to him for an exhibition. This was part of a series involving leading artists, entitled 'The Artist's Eye'. Freud's selection was shown during the summer of 1987. The artists he chose included Velázquez, Rembrandt, Hals, Rubens, Chardin, Constable, Turner, Ingres, Daumier, Degas, Whistler, Monet, Seurat, Cézanne and Vuillard. In the course of his selection, Freud became interested in the foreground of Turner's painting *Sun rising through vapour: fishermen cleaning and selling fish*, 1807. He proceeded to make a highly individualistic drawing of the fish piled on the sand, although they are easily overlooked in Turner's painting, which contains boats, people and spectacular light effects. Freud's drawing, using white chalk in addition to charcoal on grey paper, glows with a surreal phosphorescence. Through selection and omission, Freud has created a work of originality, while encouraging us to scrutinize further the painting that inspired him. It is a drawing that pays homage to but is not subservient to Turner.

Lucian Freud, now entering his fifth decade as an artist, has never worked with more confidence. It is not that the work has come about more easily. Freud is not afraid to exhibit the effort of his process or the fatigue of his sitters. 'I remember everything I've done because it was done with difficulty', Freud once said.[18] What distinguishes his present output, however, is the consistency and originality apparent in all aspects of his art, from painting and drawing to printmaking.

Cézanne once wrote: 'The artist must scorn all judgment that is not based on the intelligent observation of character.'[19] Uncompromising loyalty to an art based on observable fact describes Lucian Freud's long and remarkable career. He has created some of the most provocative and disturbing images of our time. His examination of human character will inform and enlighten future generations about the difficult era in which we live.

1. J. M. and M. J. Cohen, *The Penguin Dictionary of Quotations*, (Harmondsworth, Middlesex, England: Penguin Books Ltd., 1972), p. 430, no. 20.
2. John Russell, *Lucian Freud* (London: The Arts Council of Great Britain, 1974), p. 13.
3. Brian O'Doherty, *American Masters: The Voice and the Myth* (New York: Ridge Press, n.d.), p. 14.
4. J. M. and M. J. Cohen, *The Penguin Dictionary of Modern Quotations* (Harmondsworth, Middlesex, England: Penguin Books Ltd., 1971), p. 160, no. 25.
5. Russell, p. 5.
6. Robert Goldwater and Marco Treves, eds., *Artists on Art* (New York: Pantheon Books, 1972), p. 296.
7. Cohen, *Modern Quotations*, p. 70, no. 67.
8. Russell, p. 10.
9. Lawrence Gowing, *Lucian Freud* (London and New York: Thames and Hudson Ltd., 1982), p. 112.
10. Russell, pp. 18–20.
11. Goldwater and Treves, p. 304.
12. Russell, p. 18.
13. Gowing, p. 190.
14. Ibid., p. 60.
15. Correspondence with the author, September 1987.
16. Russell, pp. 23–27.
17. Daniel Guerin, ed., *The Writings of a Savage: Paul Gauguin* (New York: The Viking Press, 1978), p. 260.
18. Gowing, p. 132.
19. Goldwater and Treves, p. 364.

Drawings 1940–1987

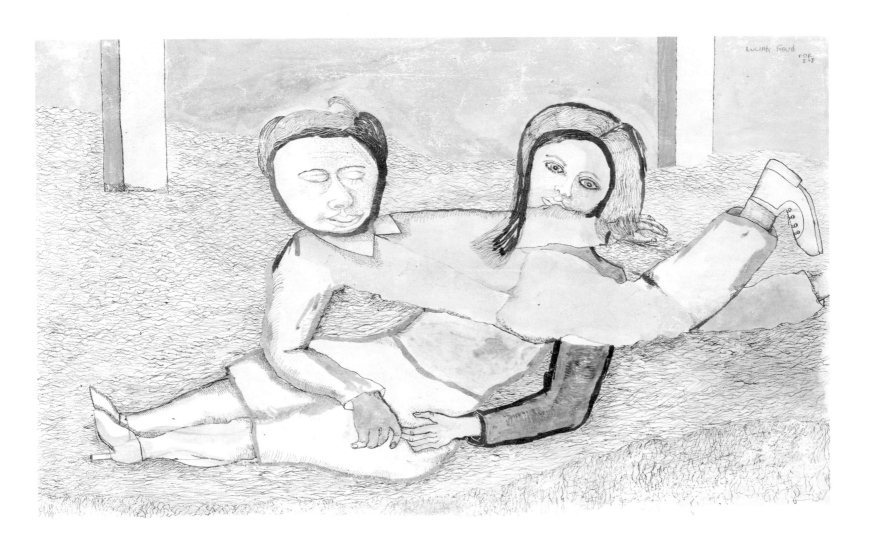

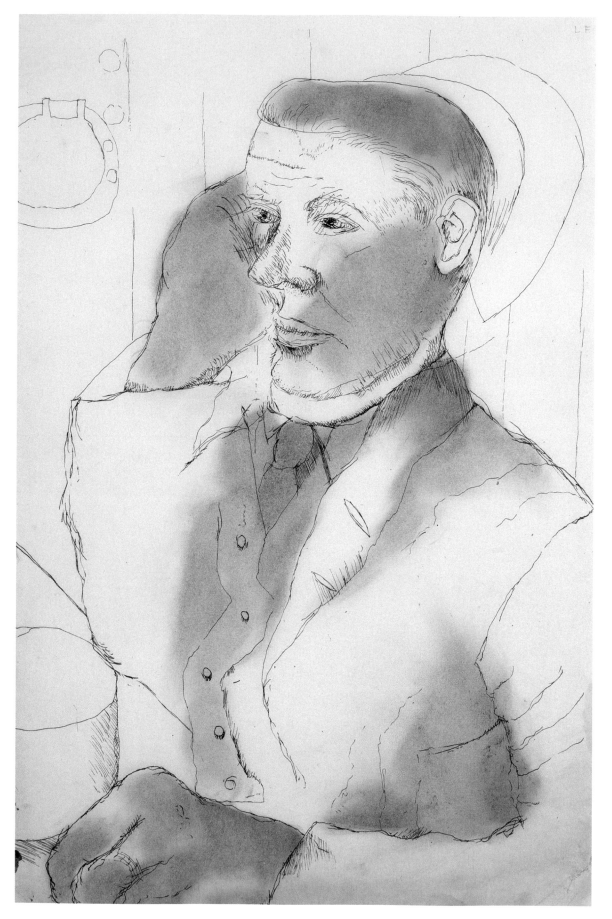

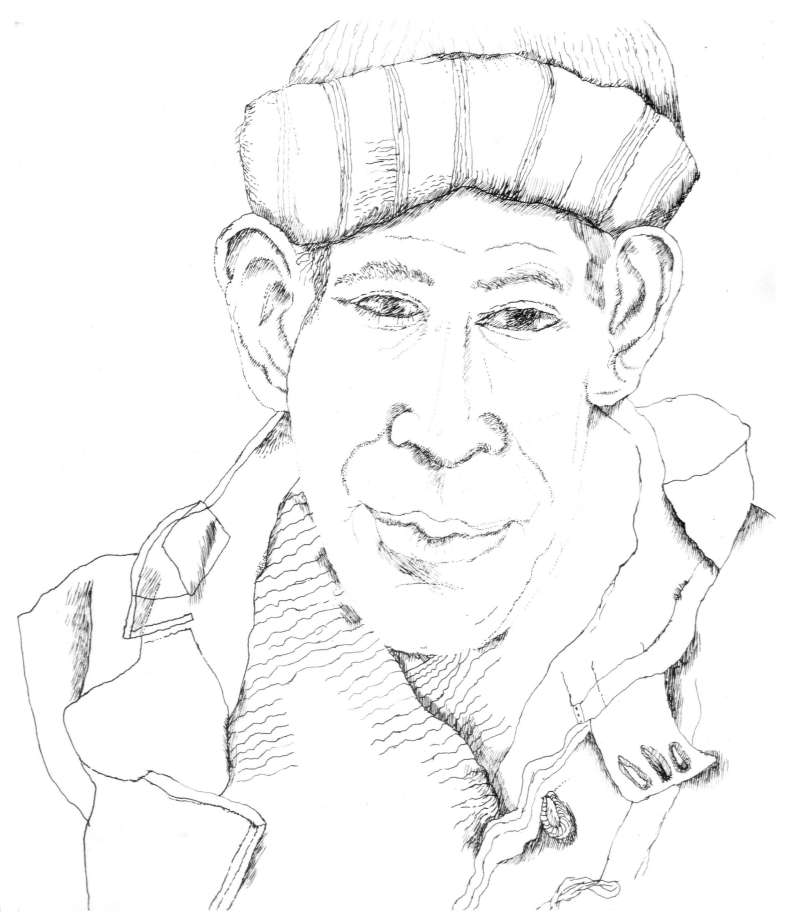

3

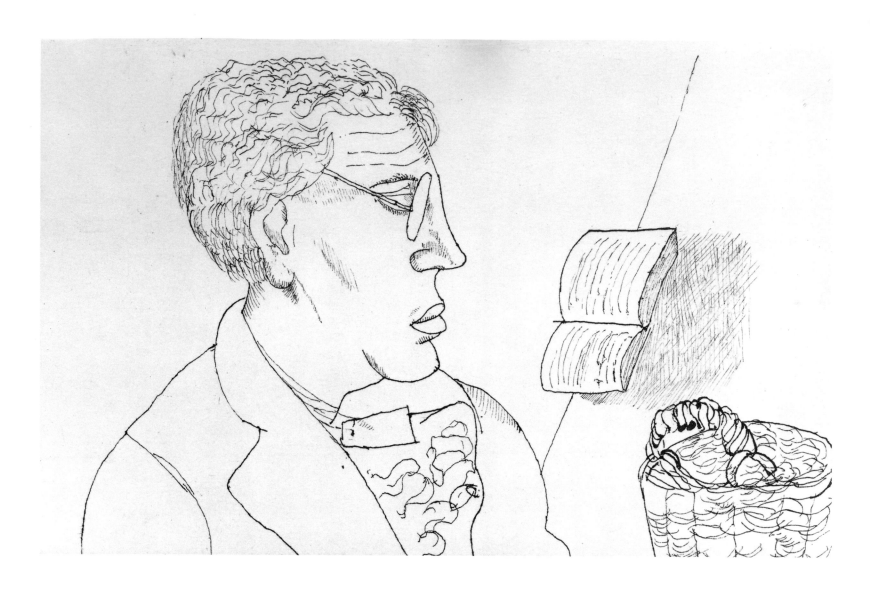

4

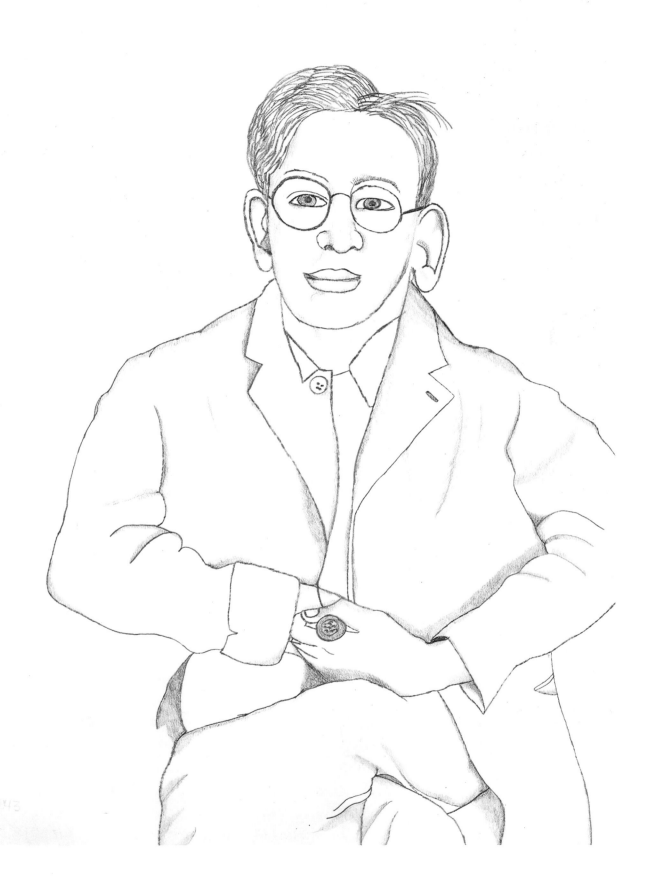

5

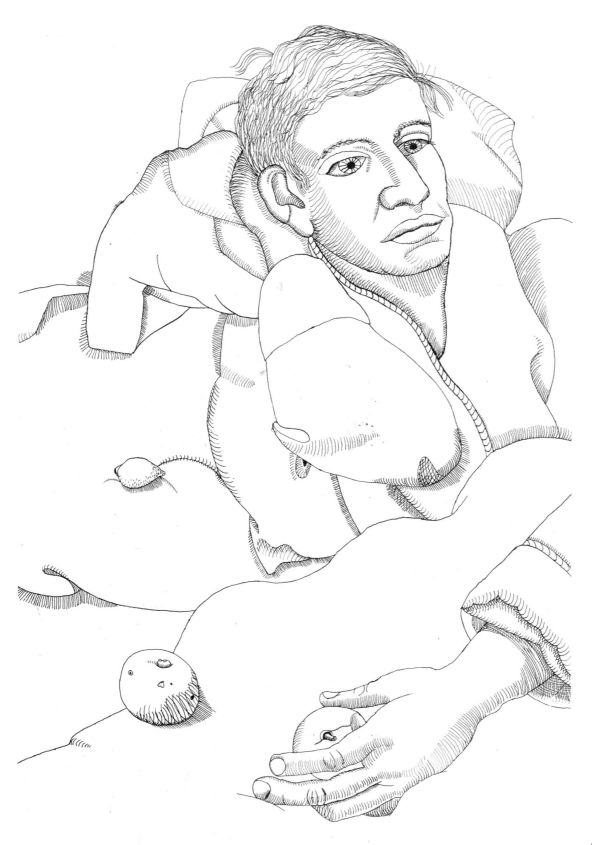

6

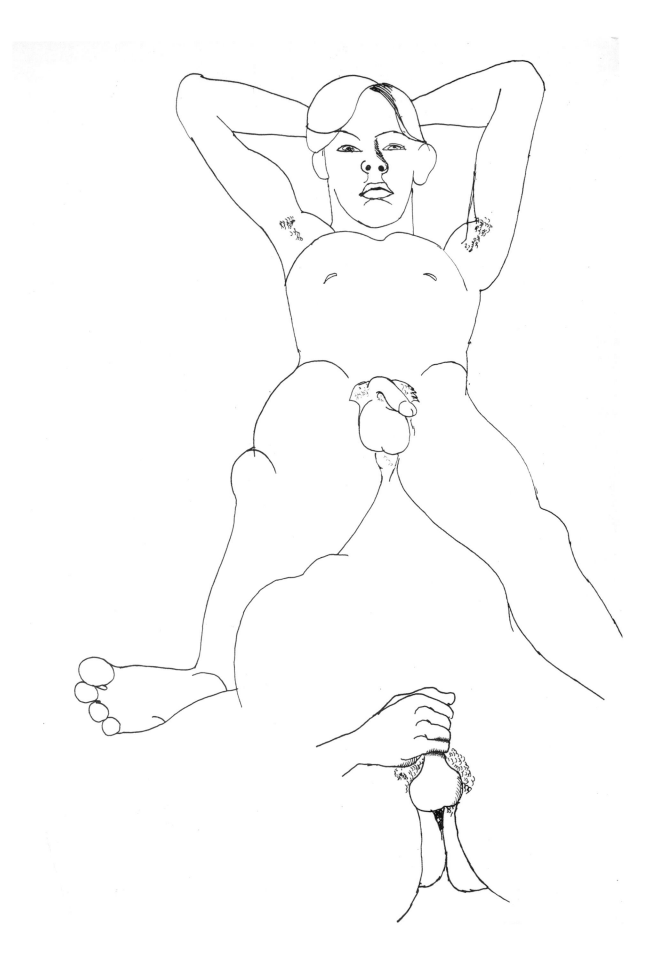

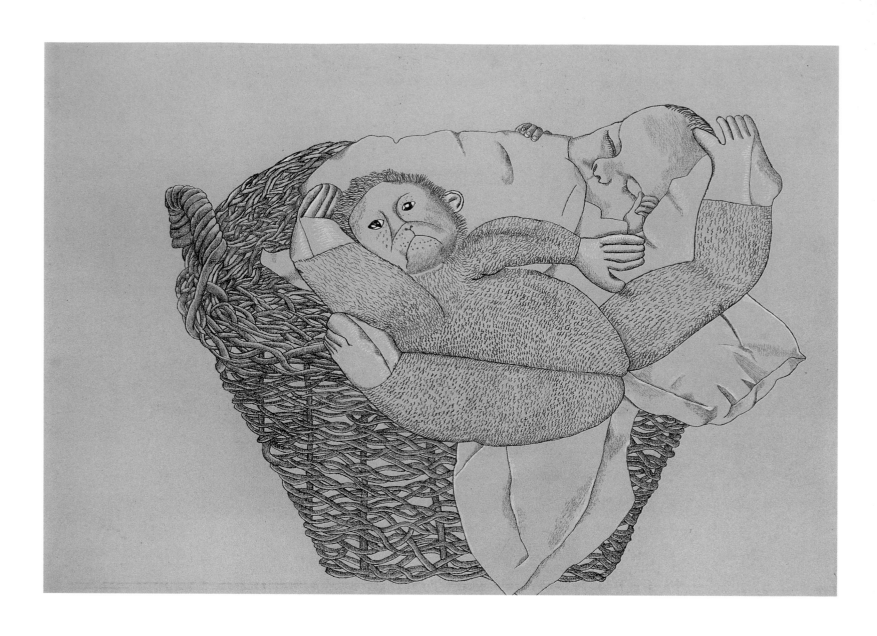

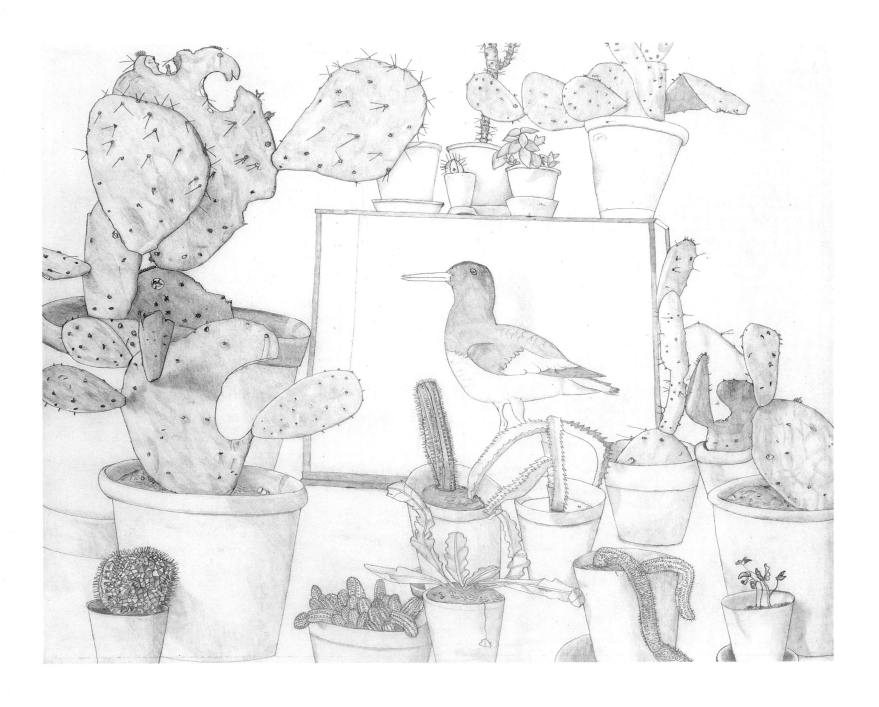

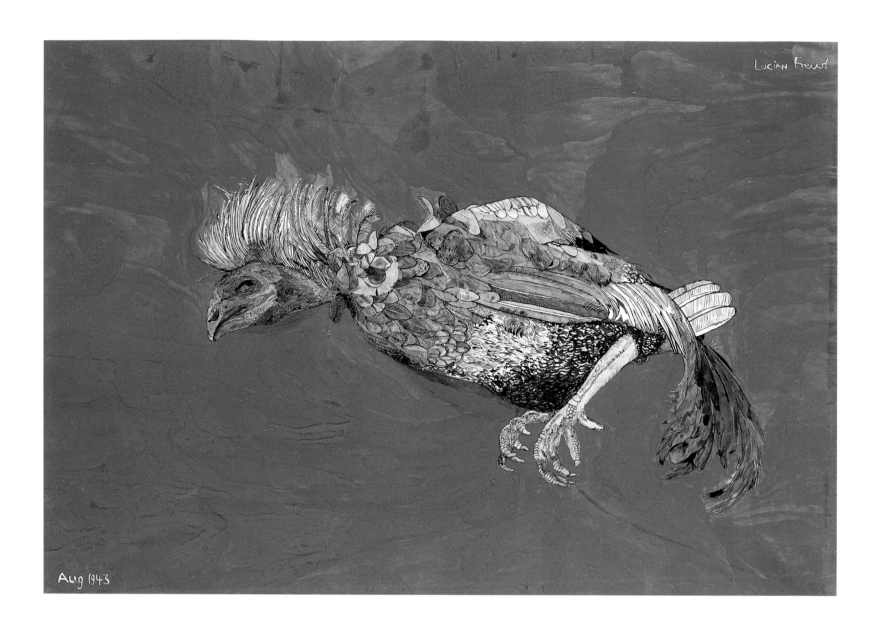

Lucian Freud

Aug 1943

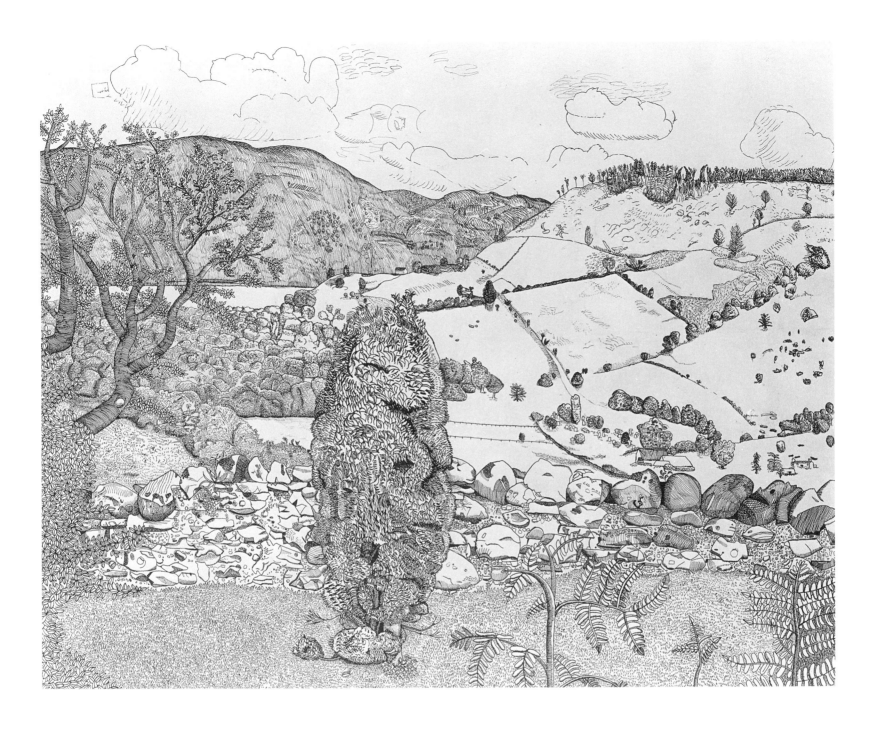

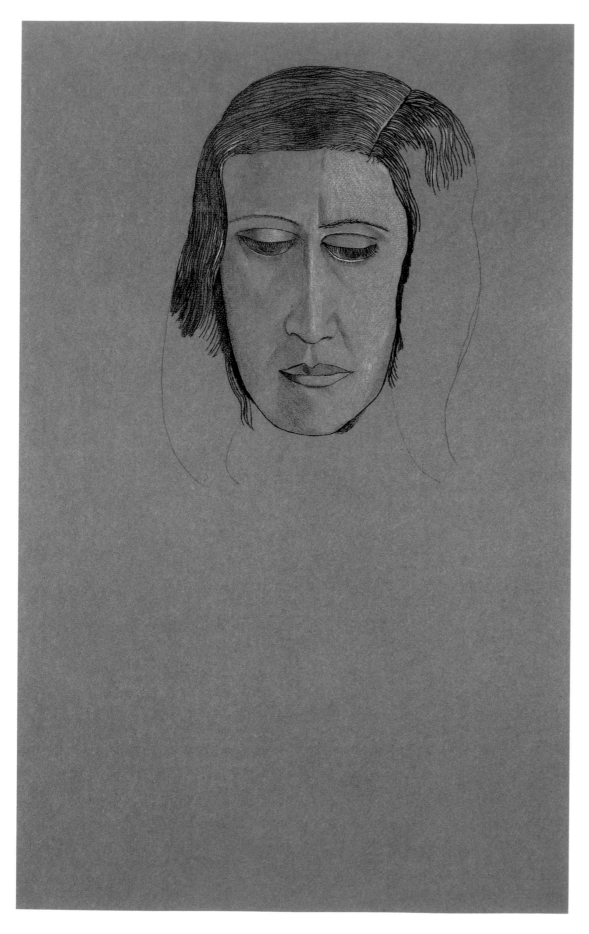

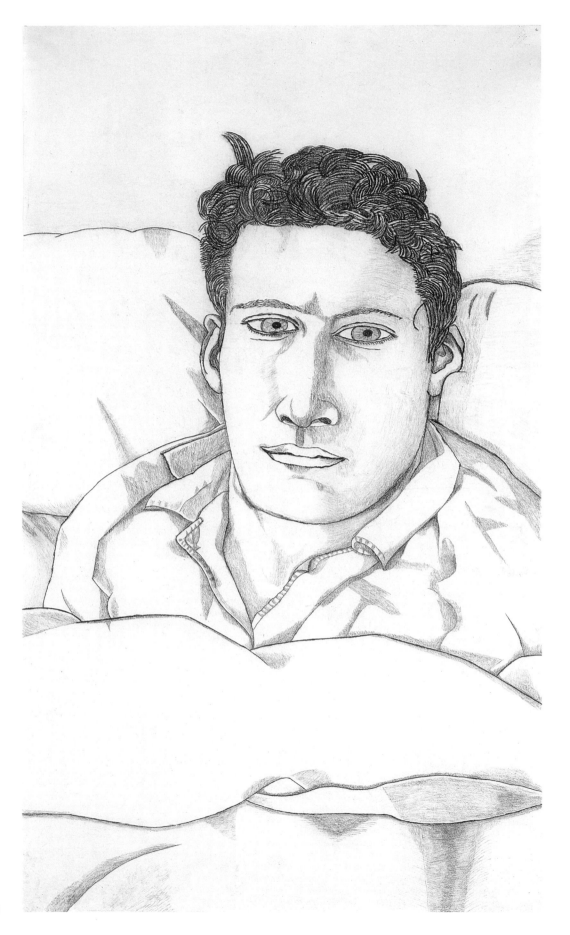

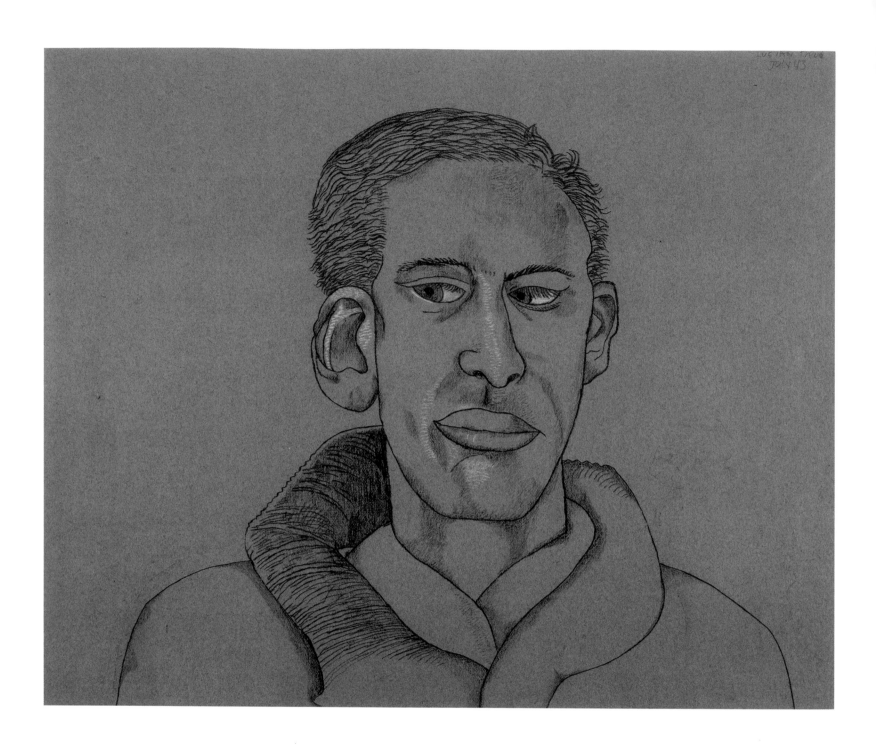

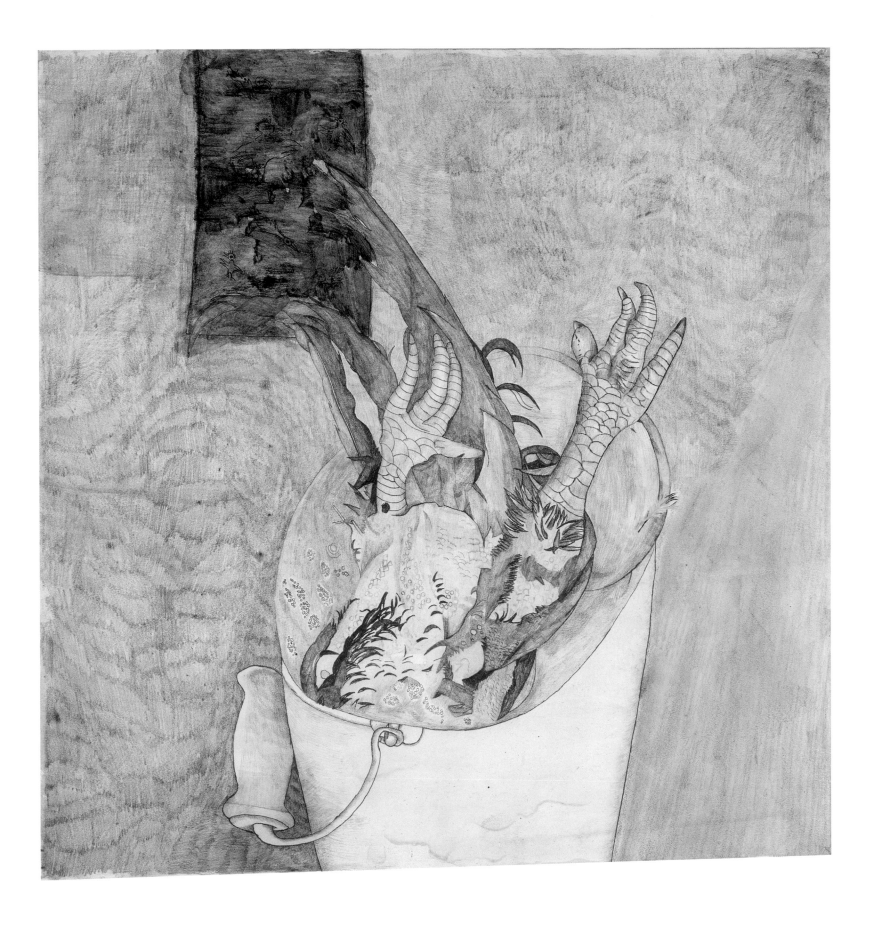

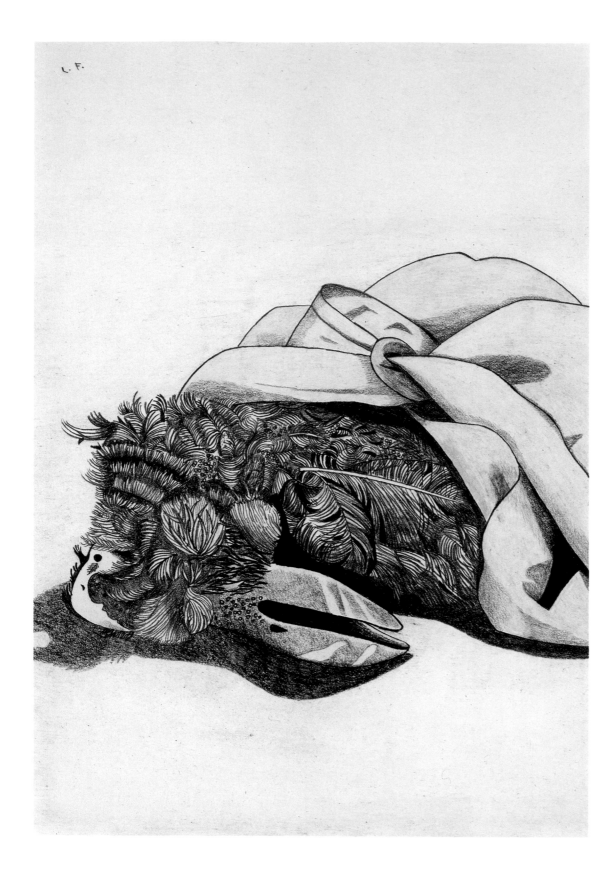

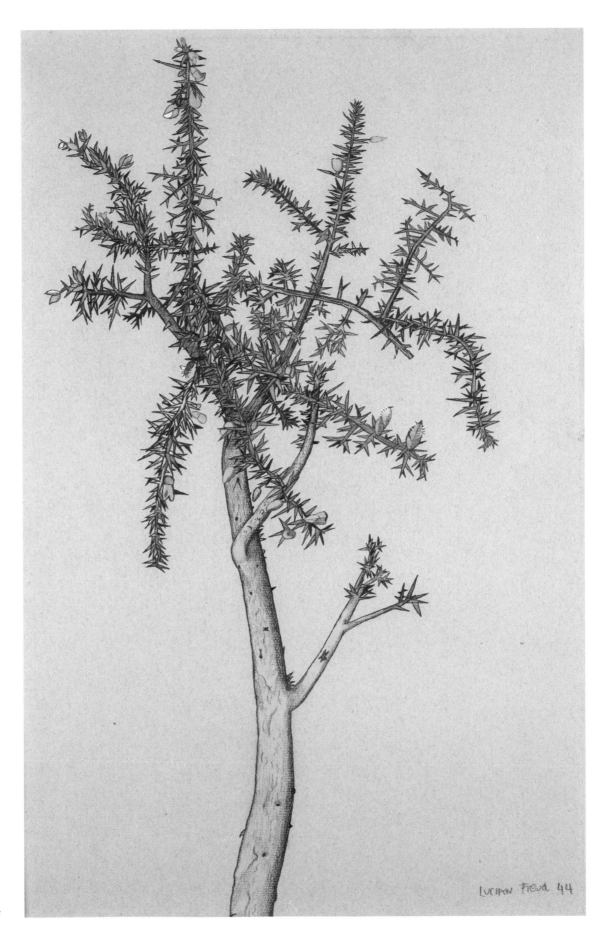

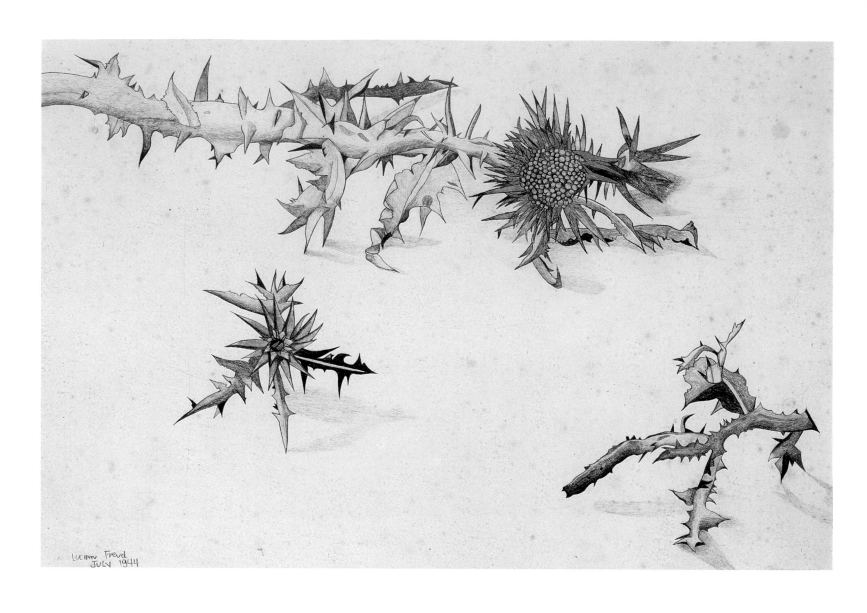

Lucian Freud
July 1944

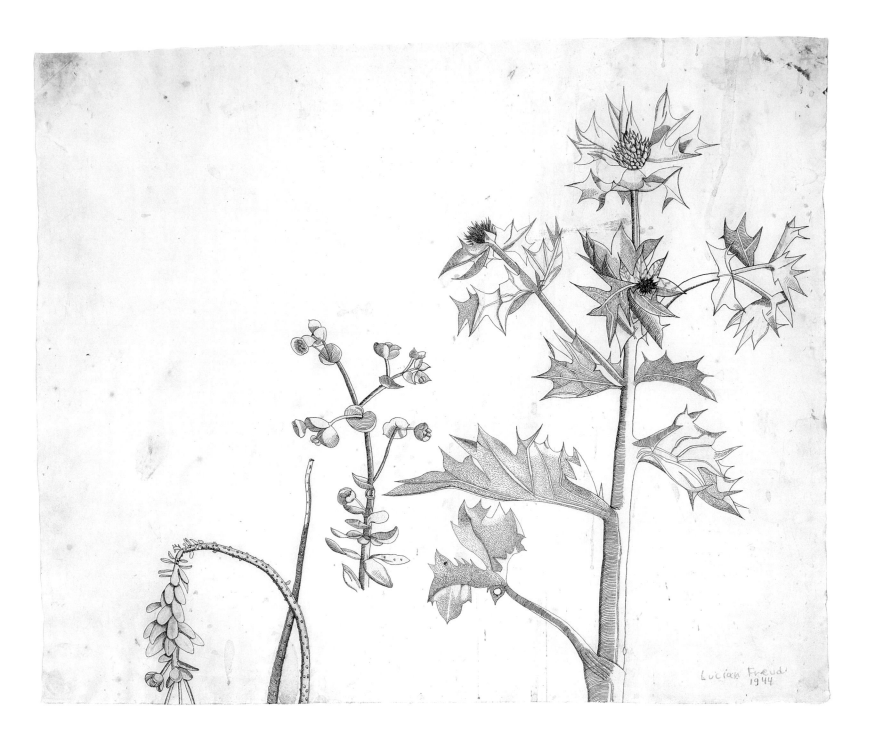

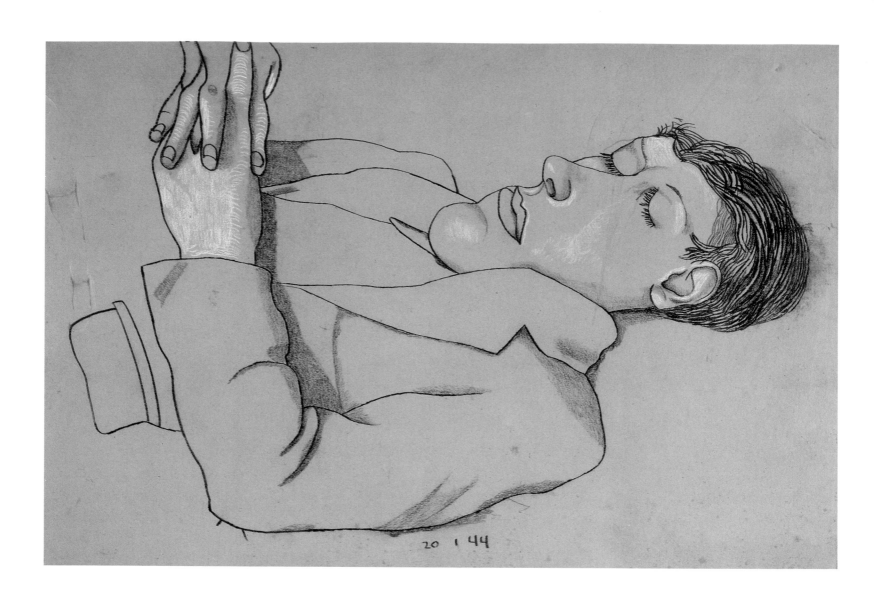

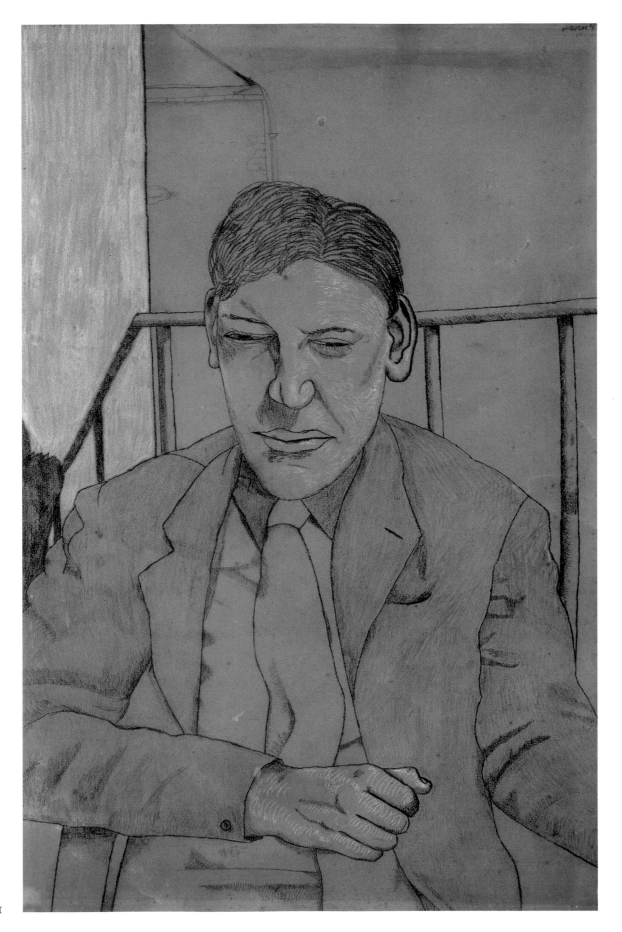

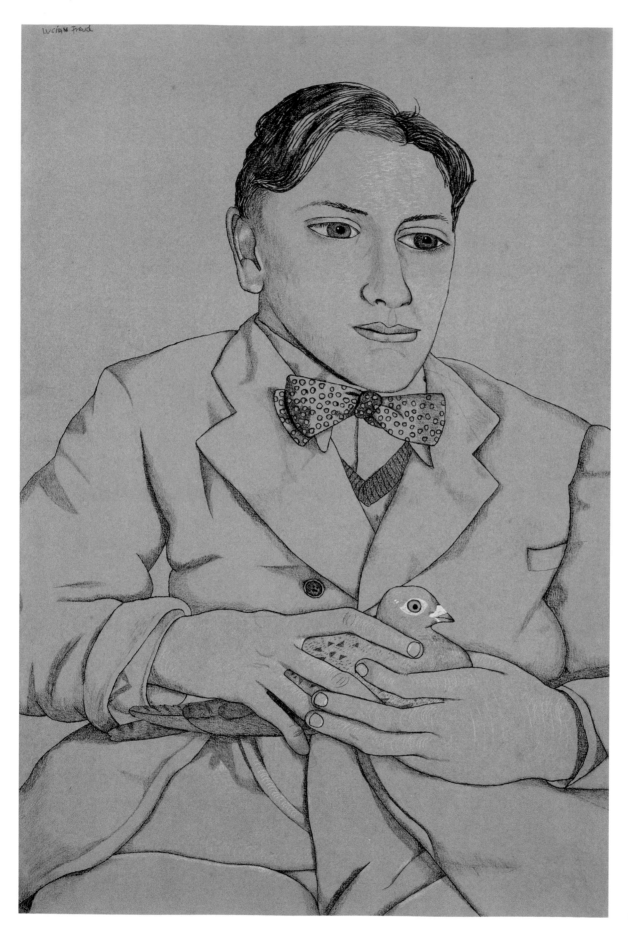

22

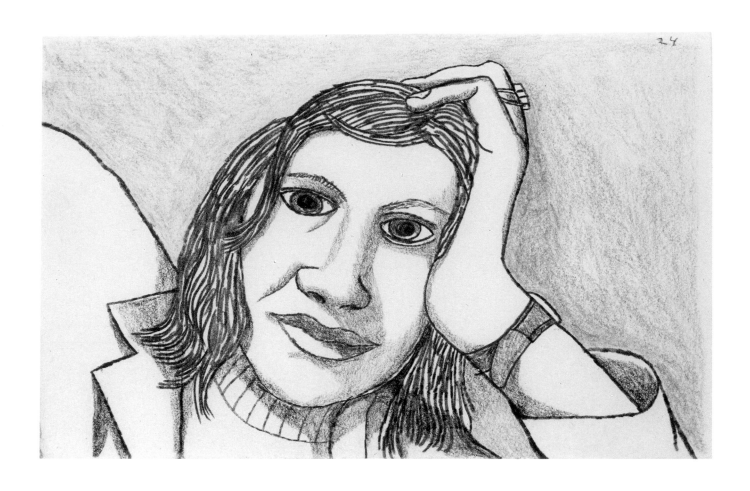

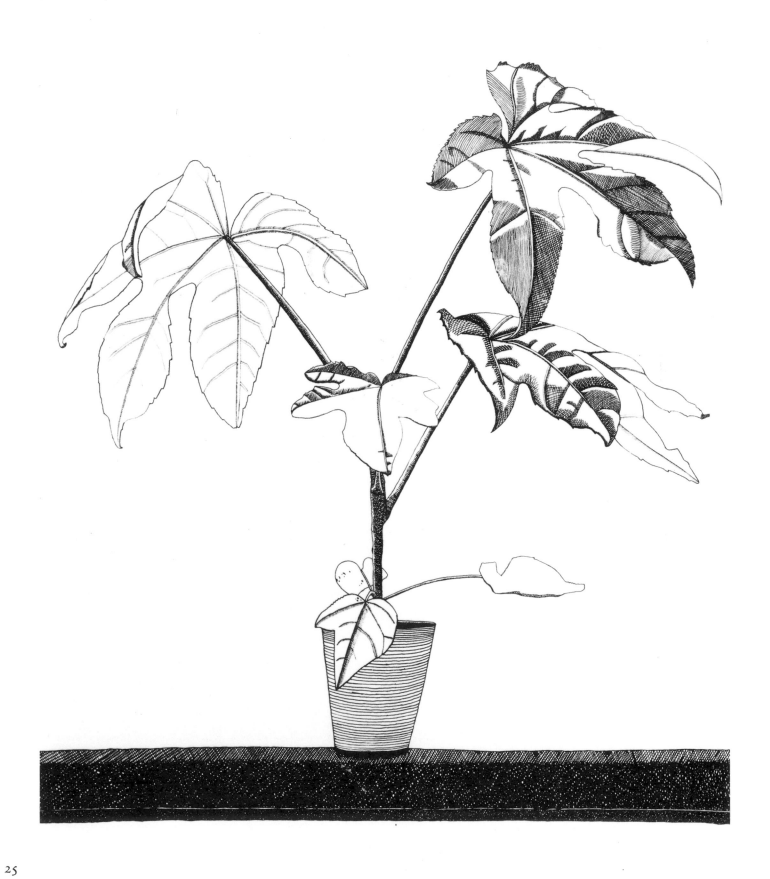

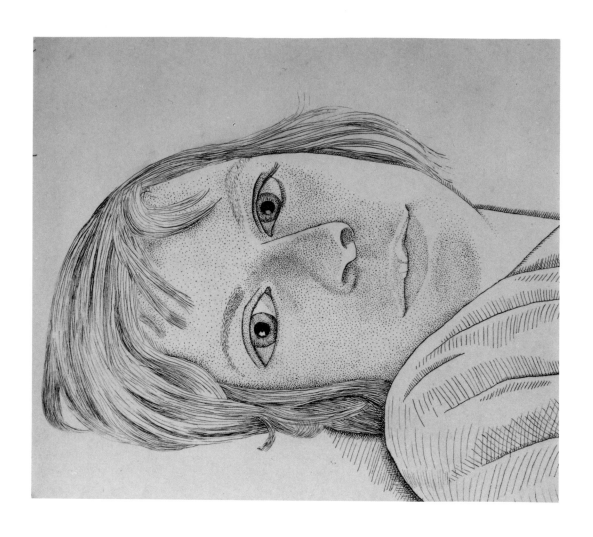

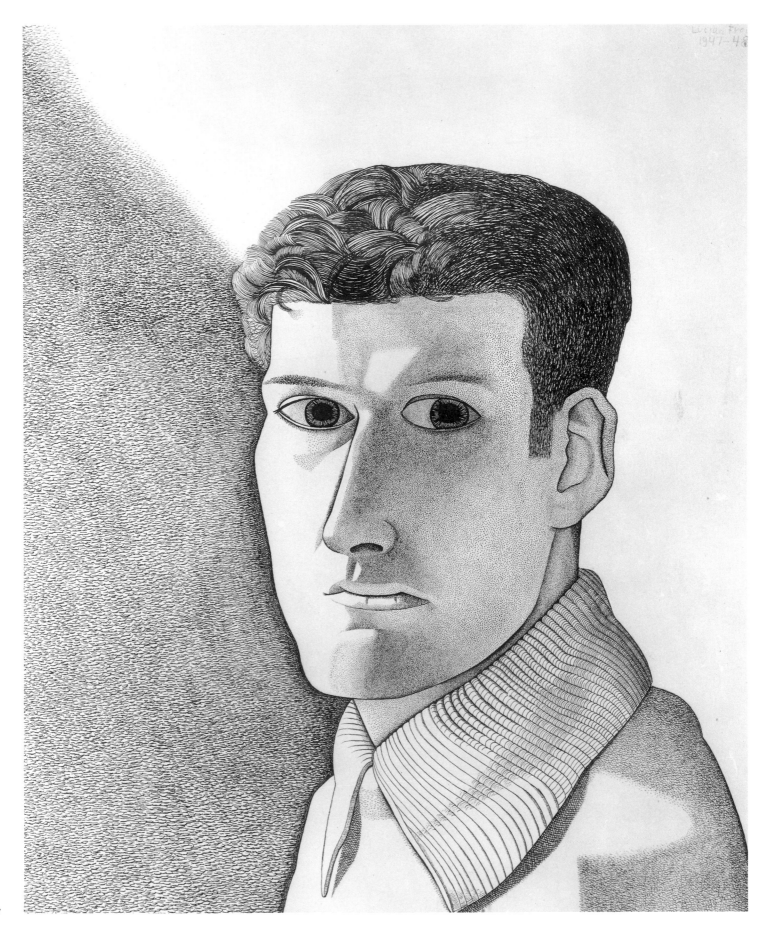

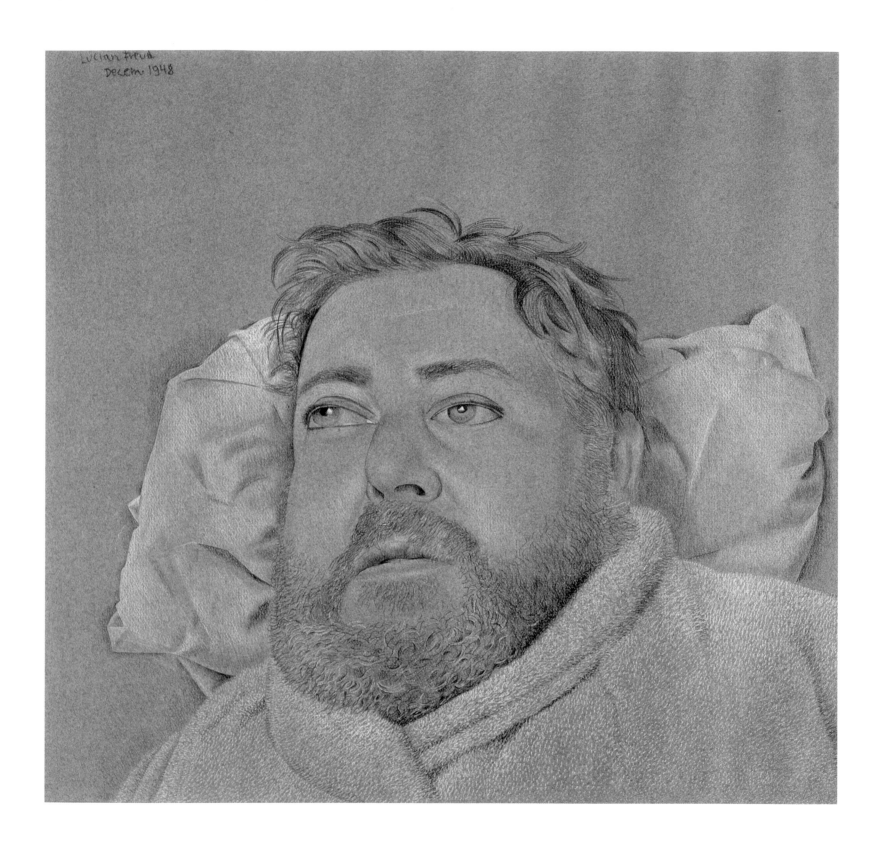

28

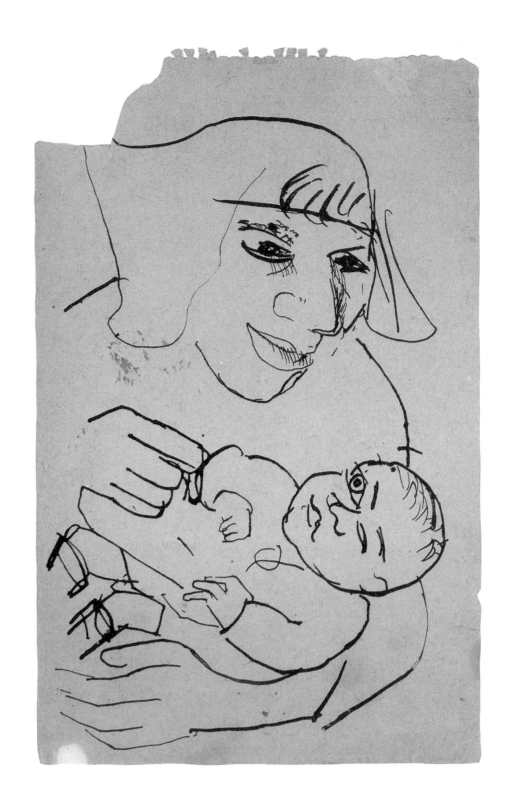

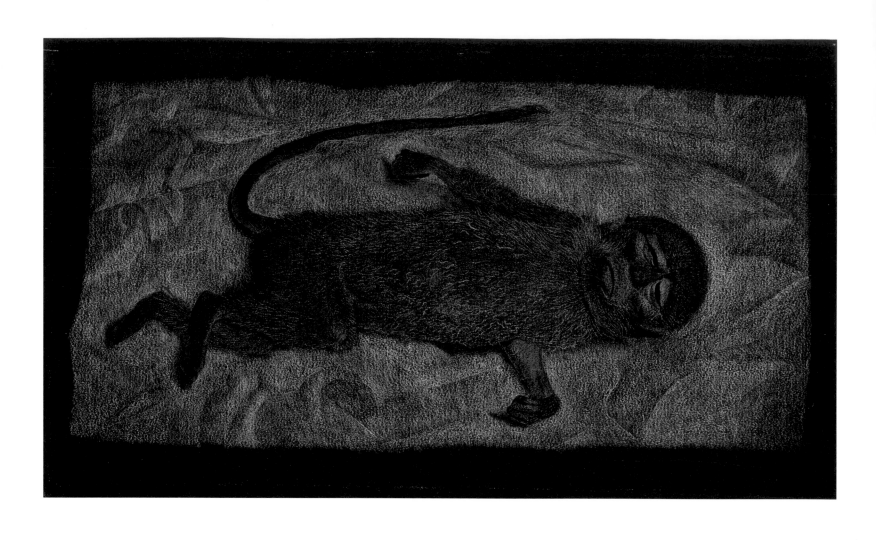

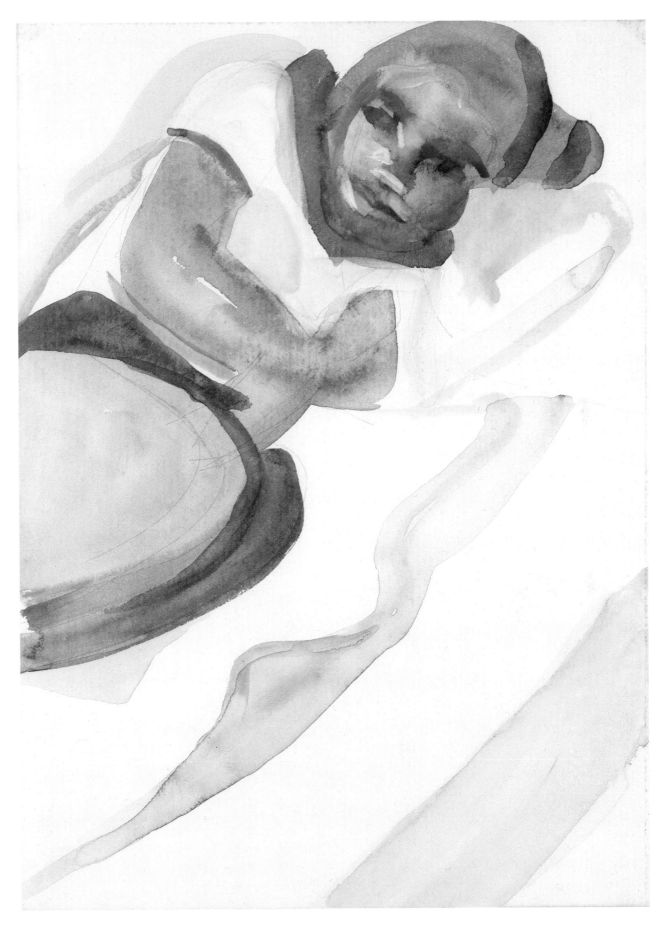

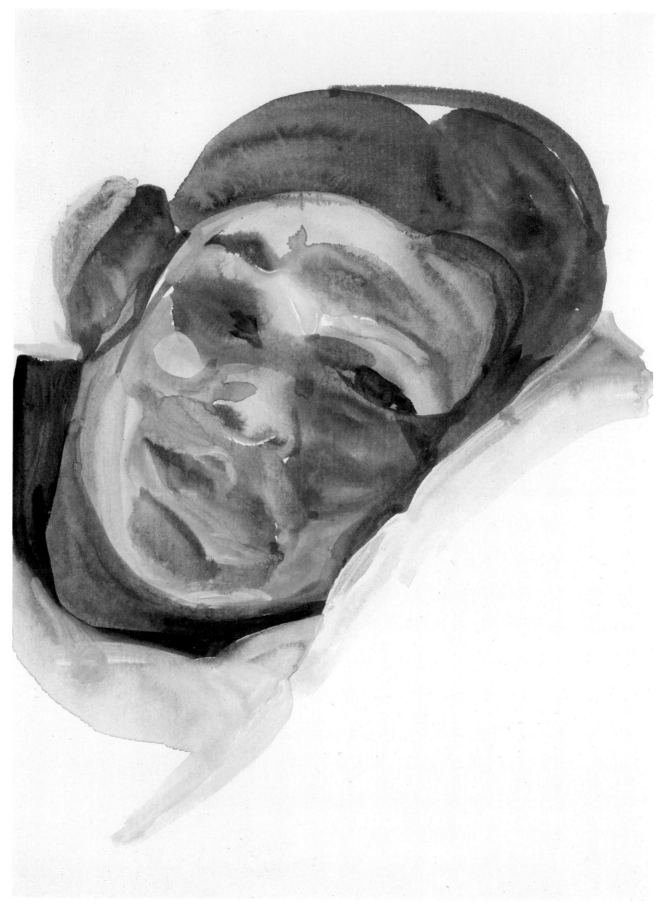

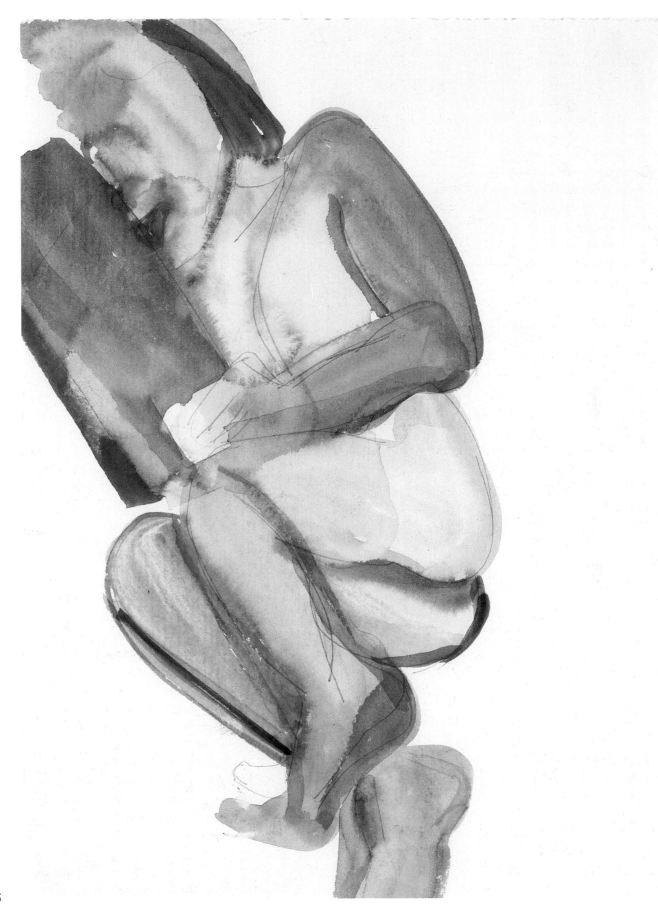

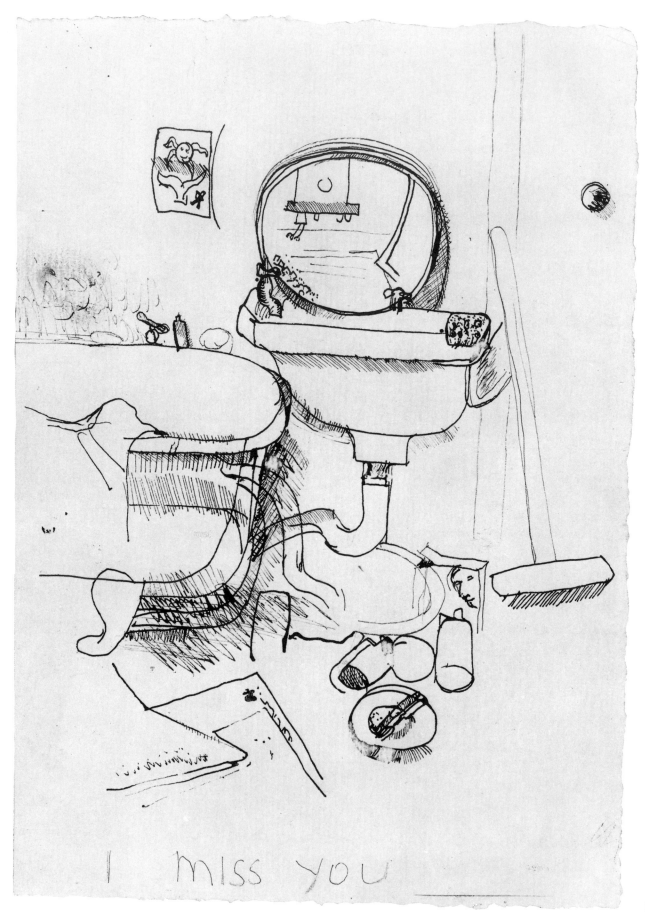

I miss you

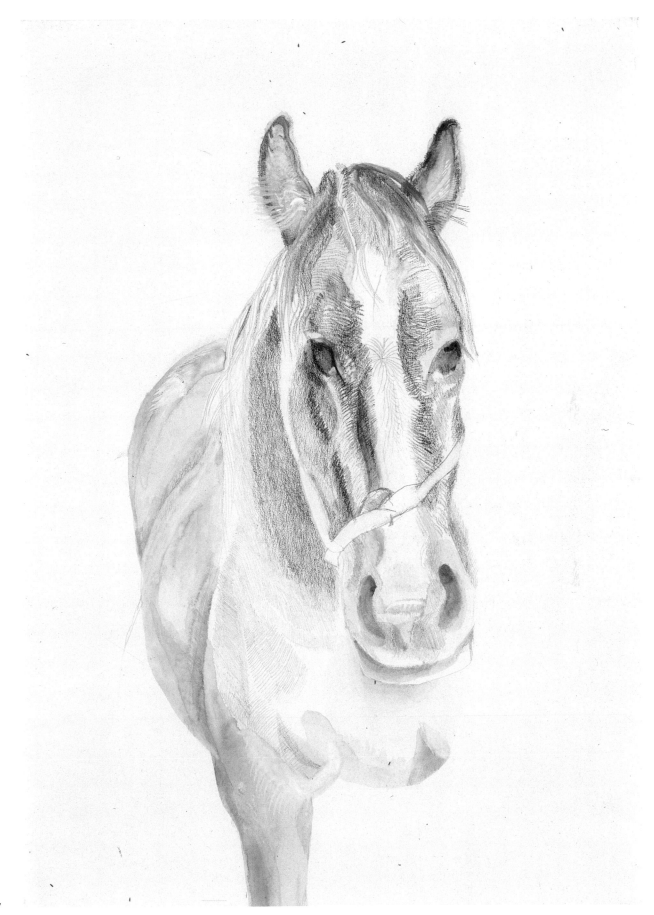

37

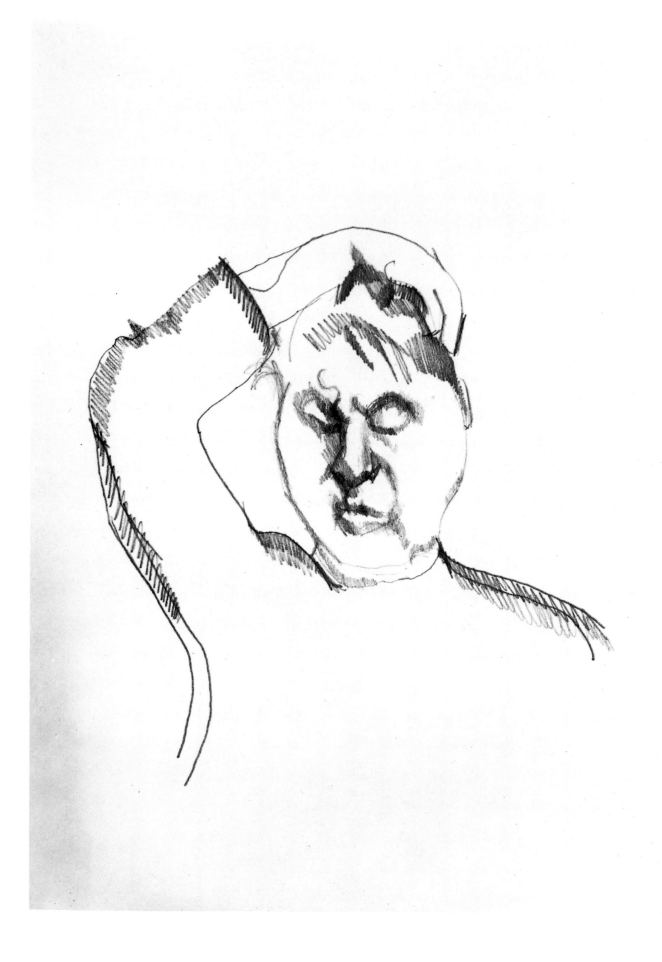

38

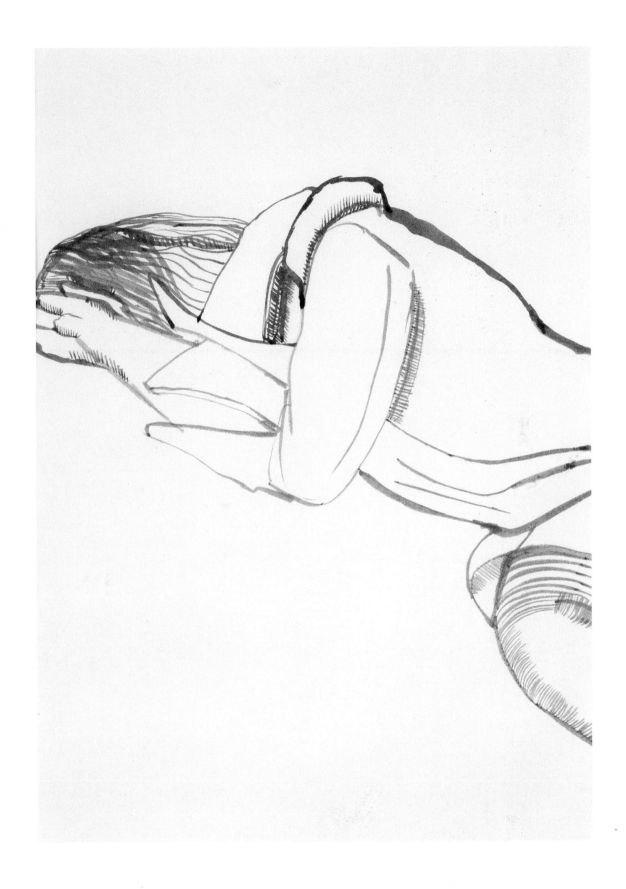

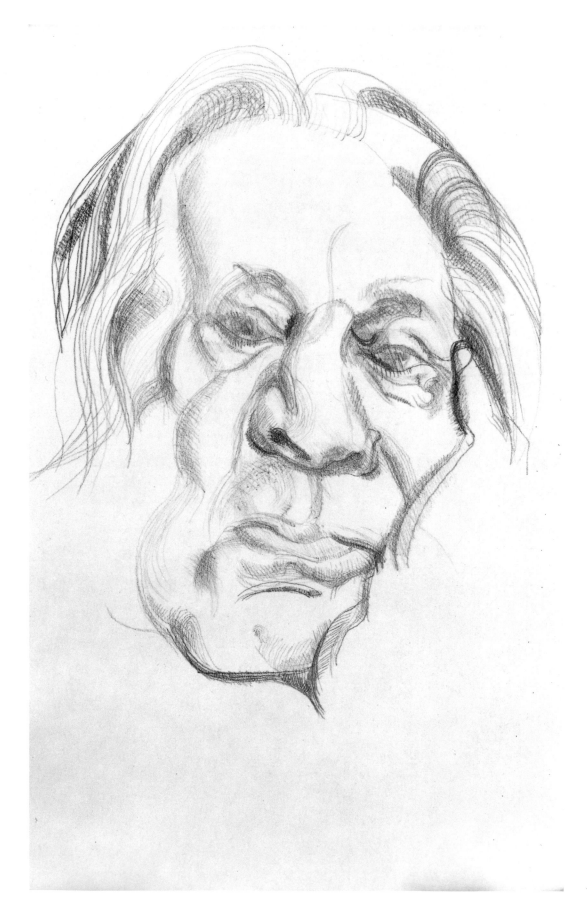

40

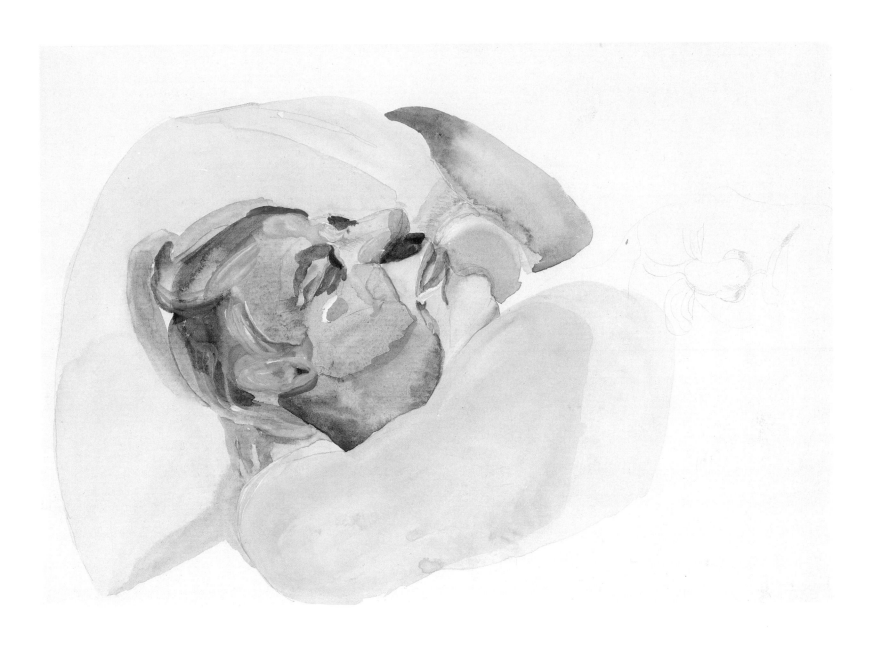

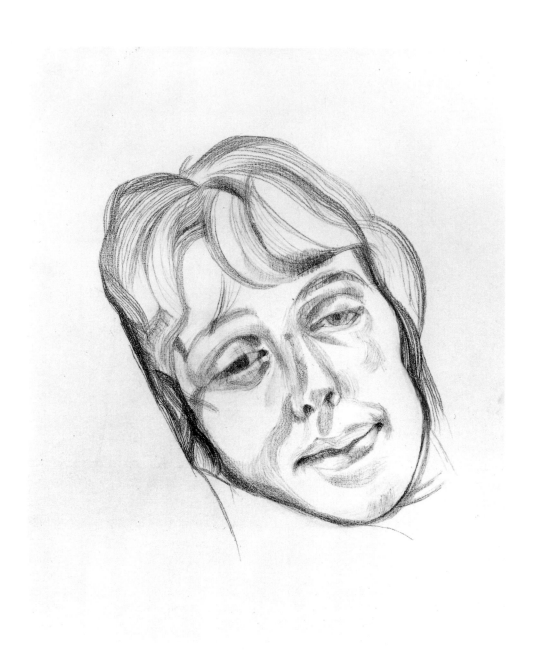

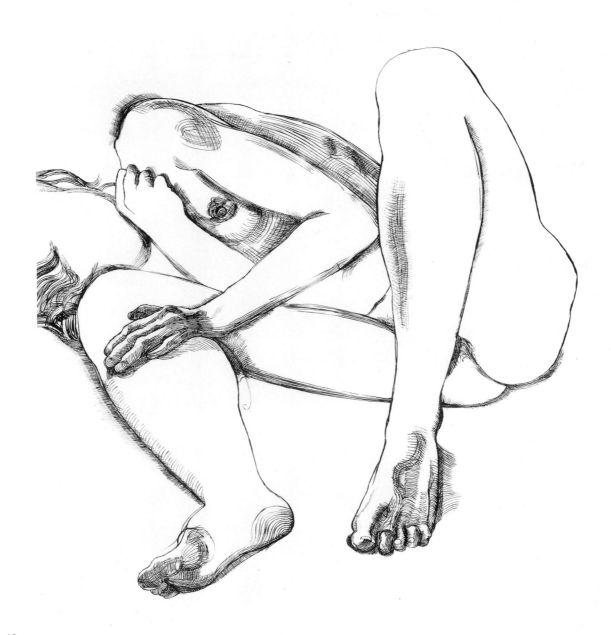

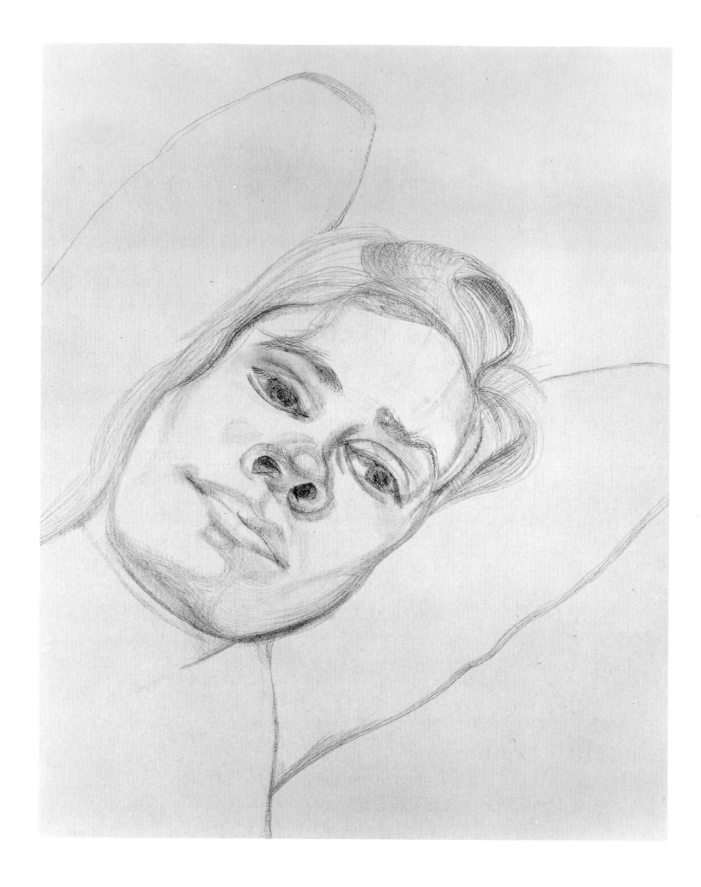

44

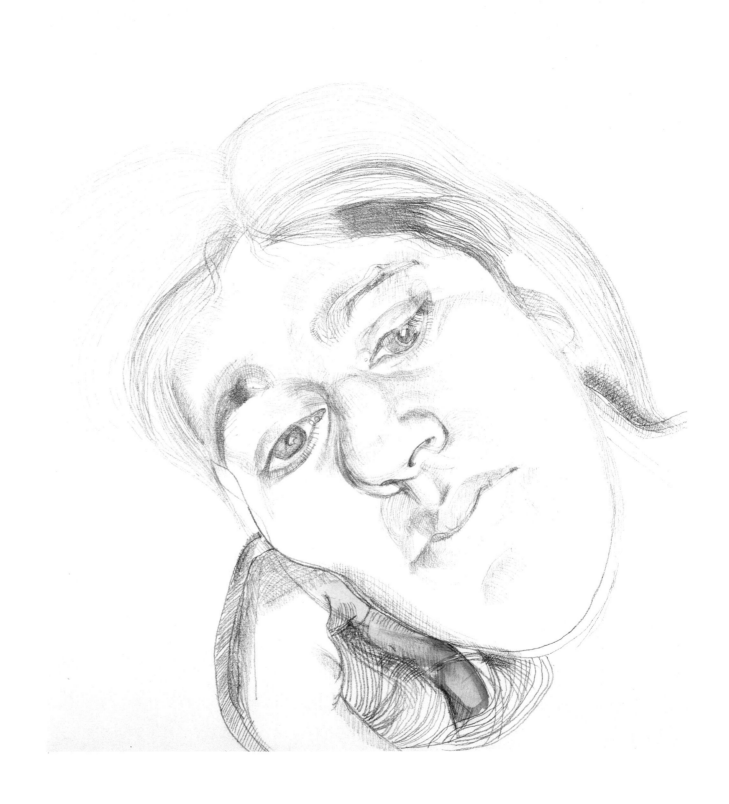

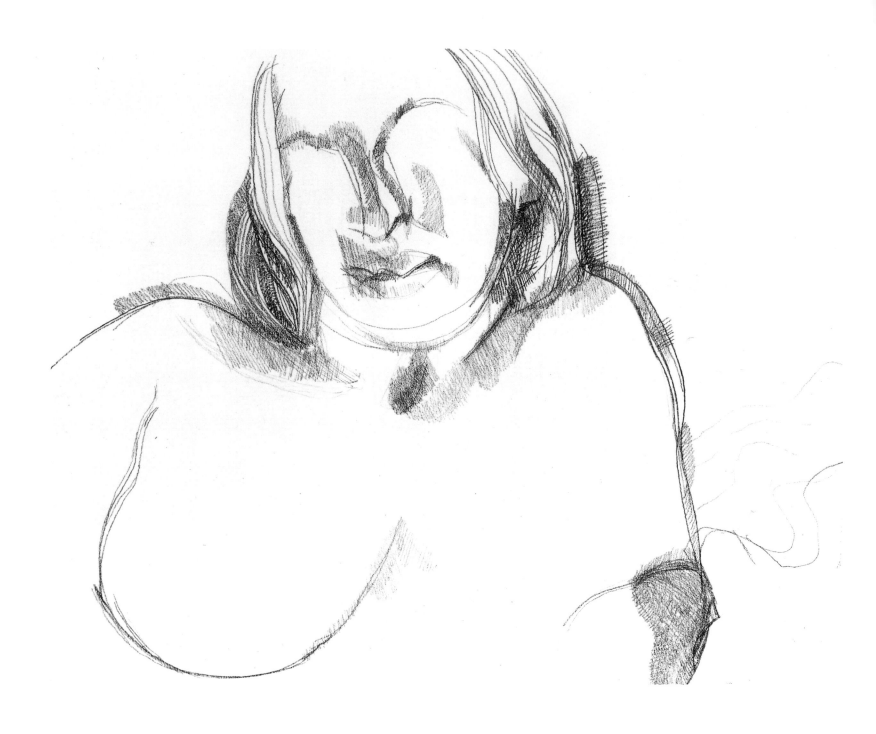

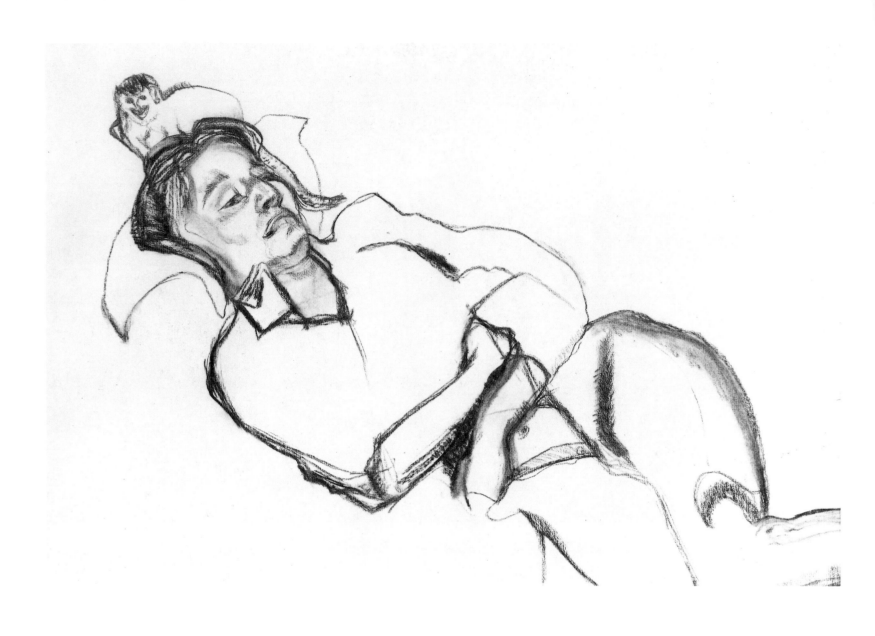

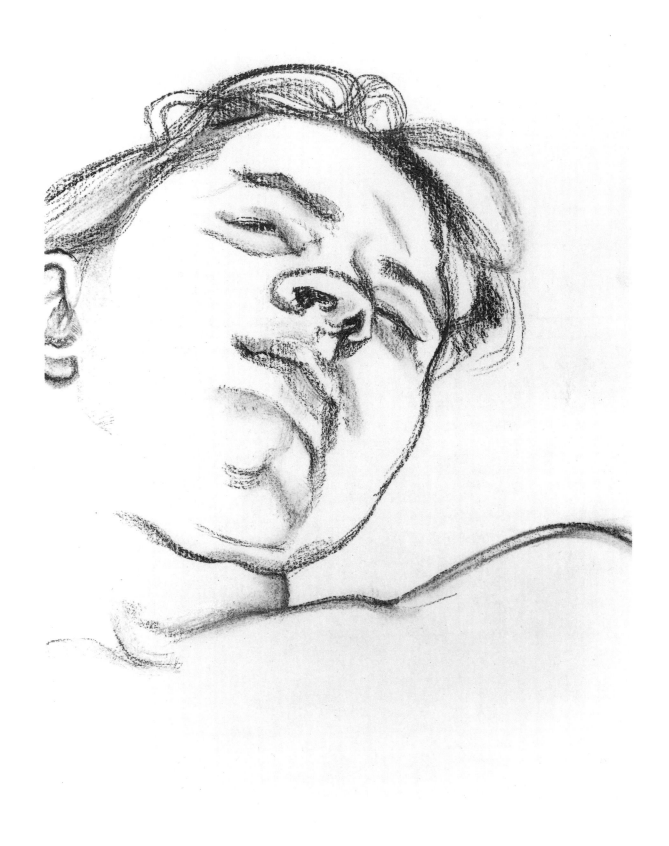

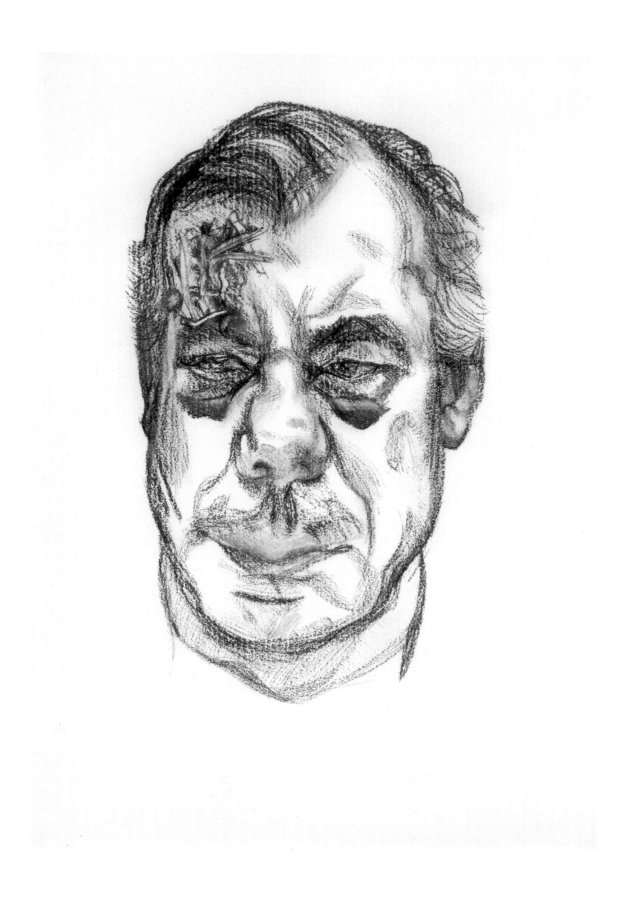

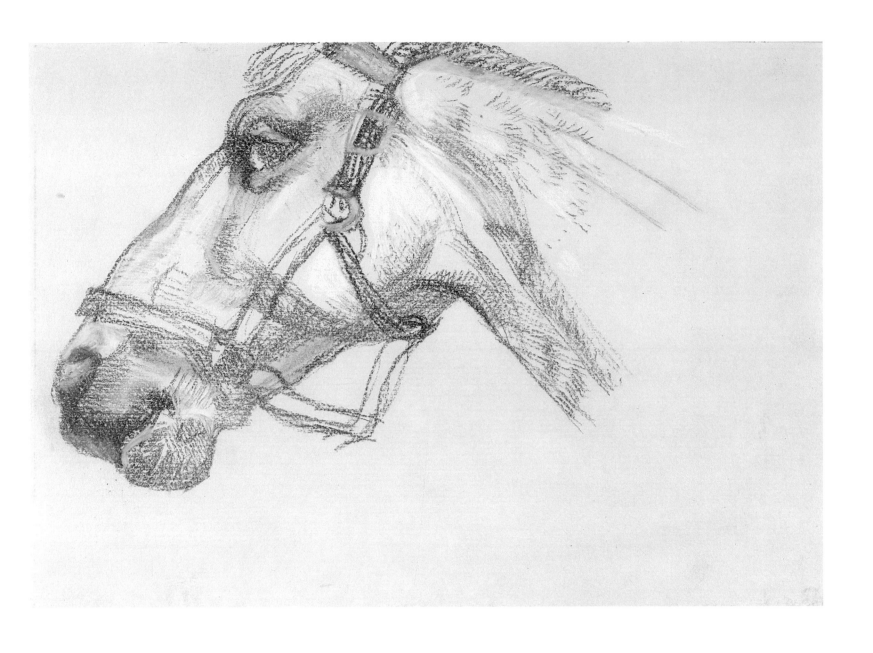

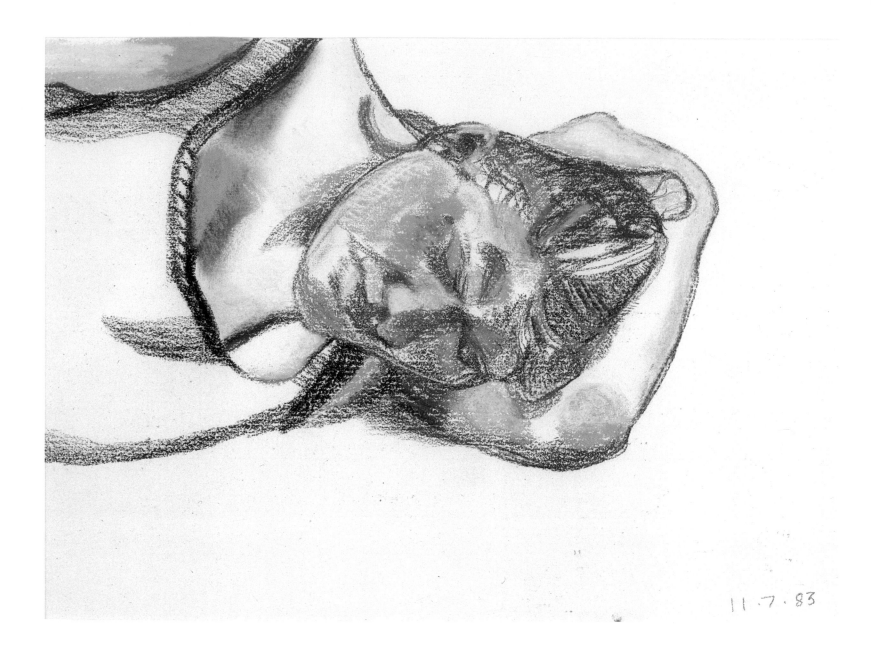

11·7·83

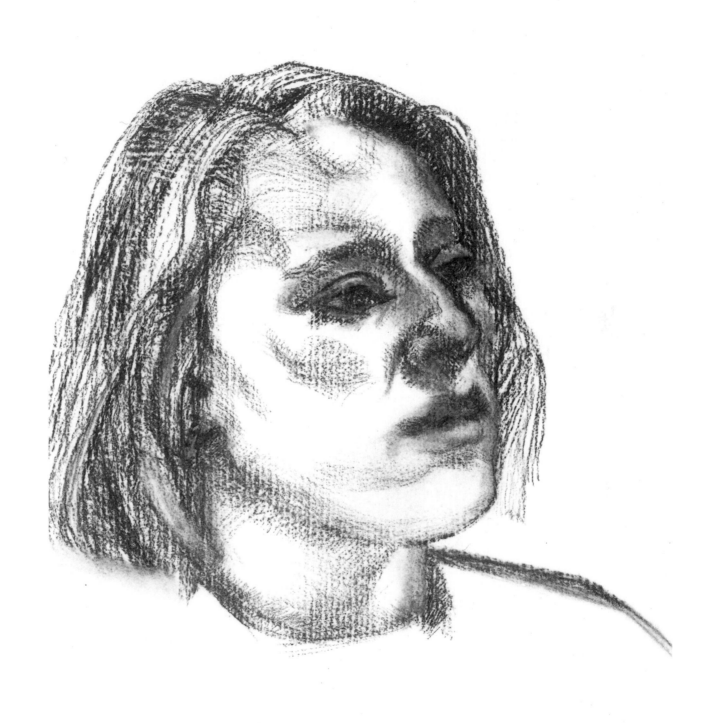

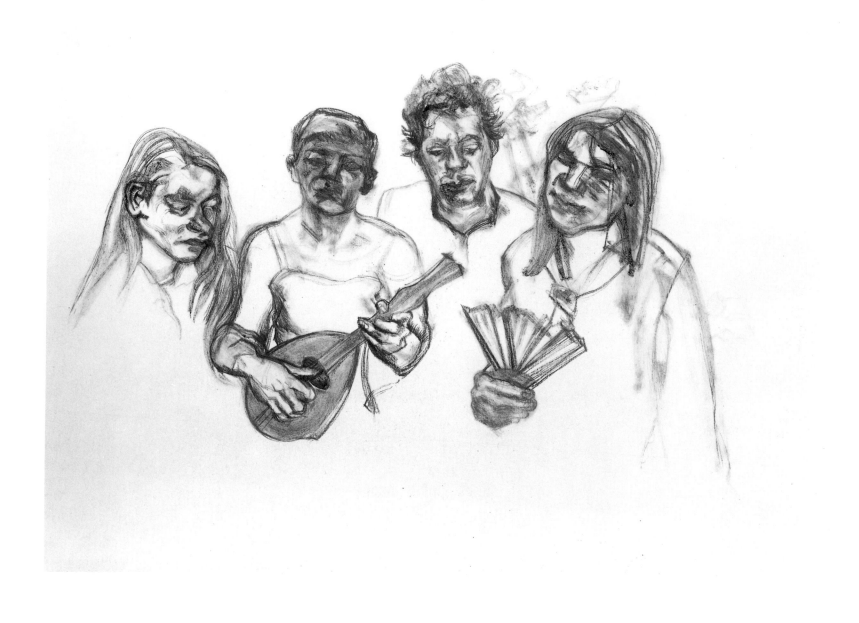

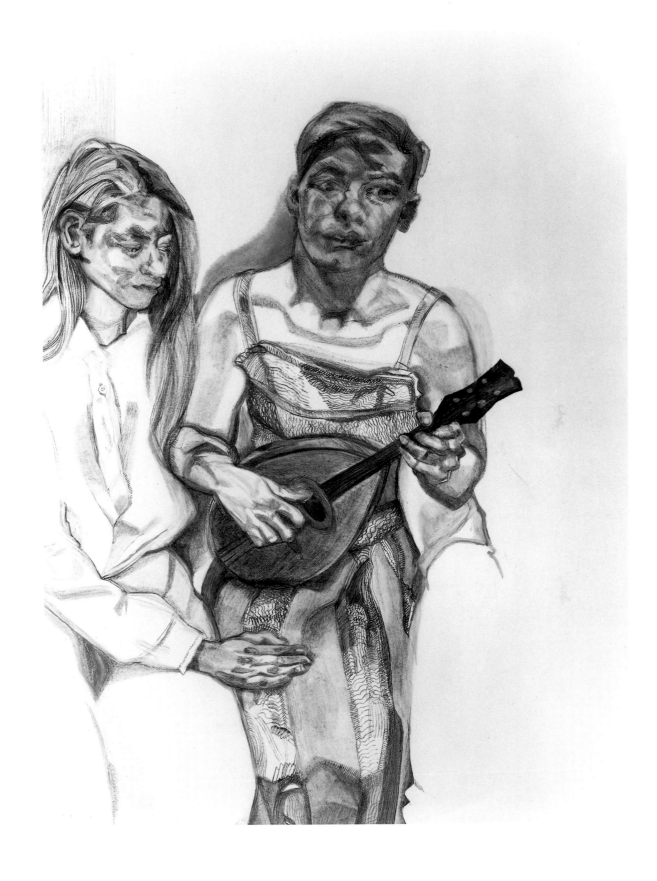

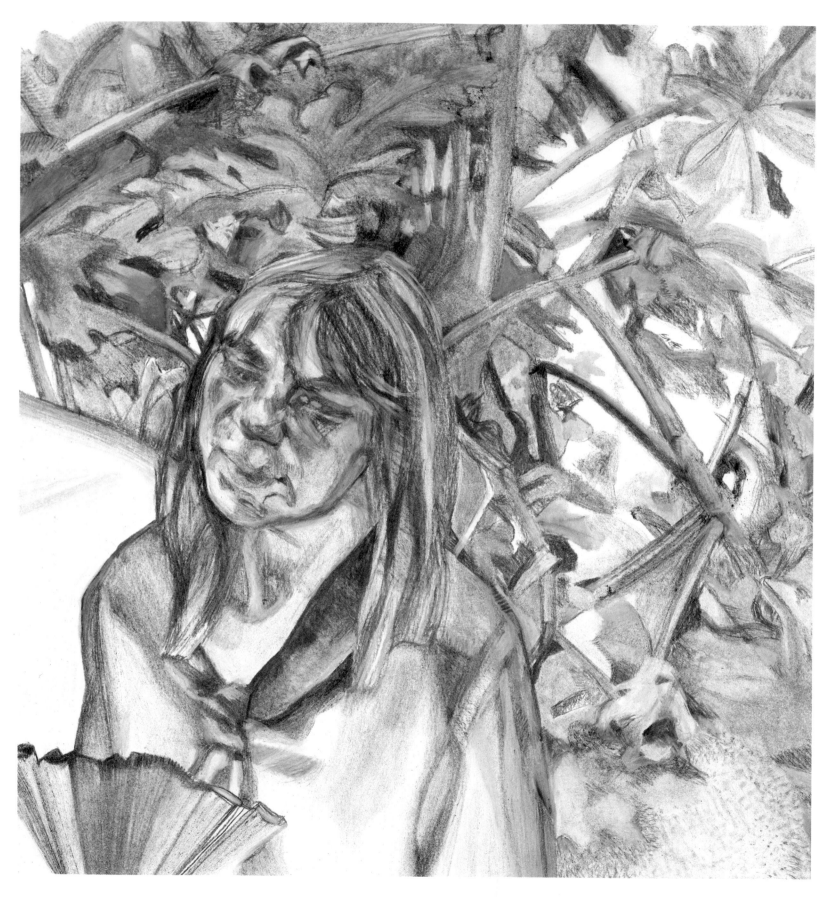

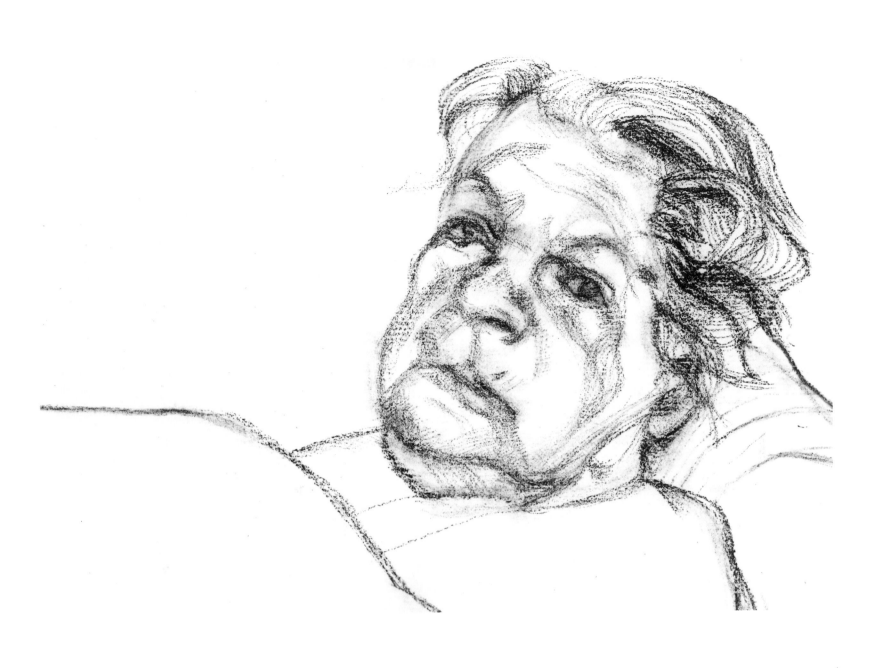

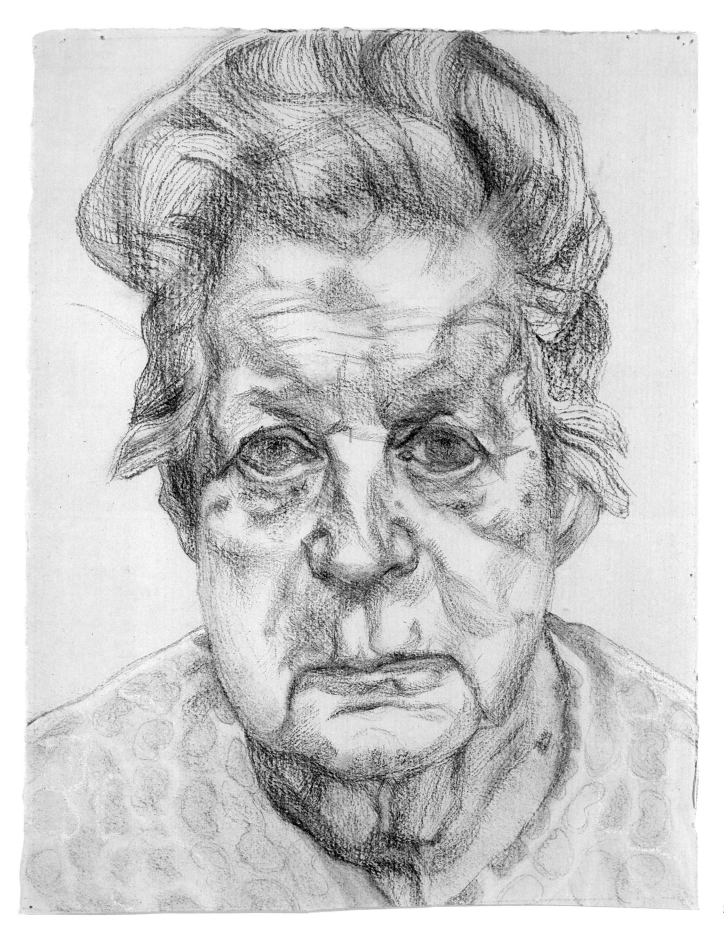

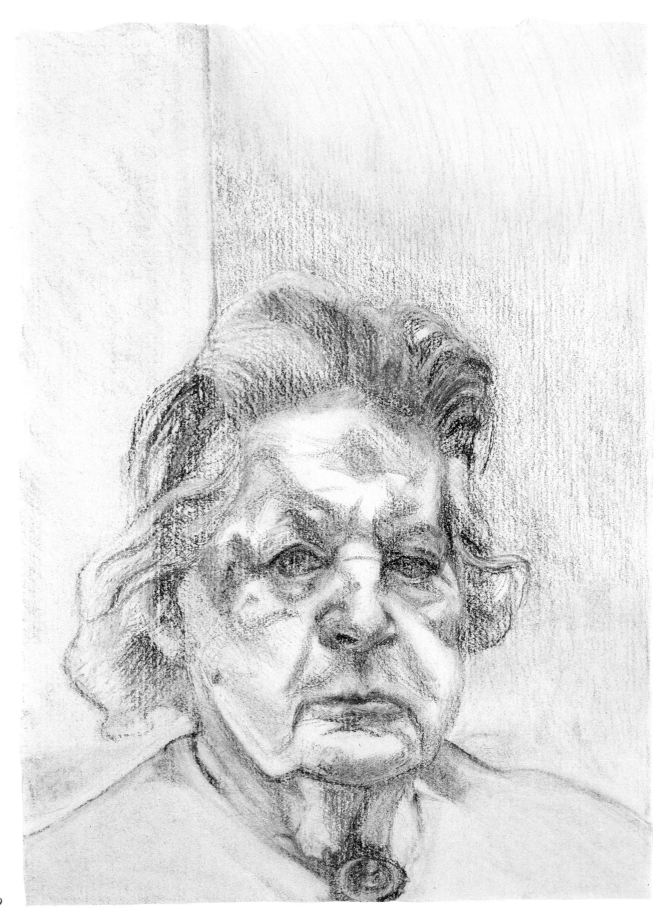

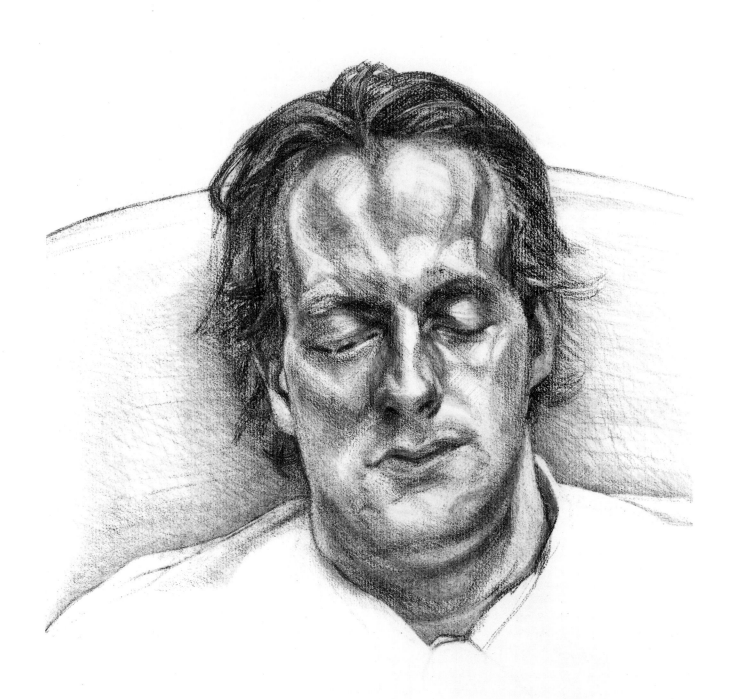

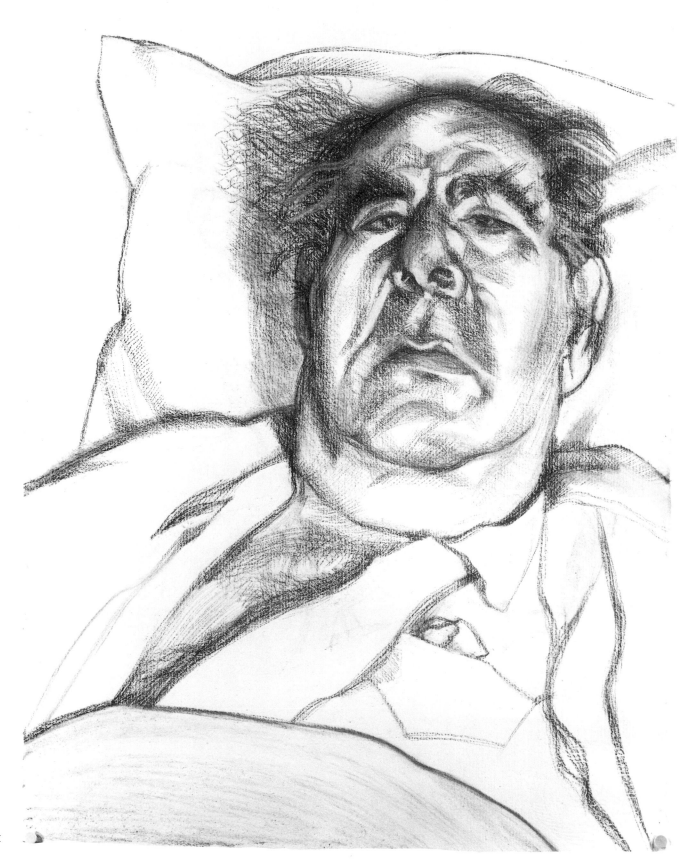

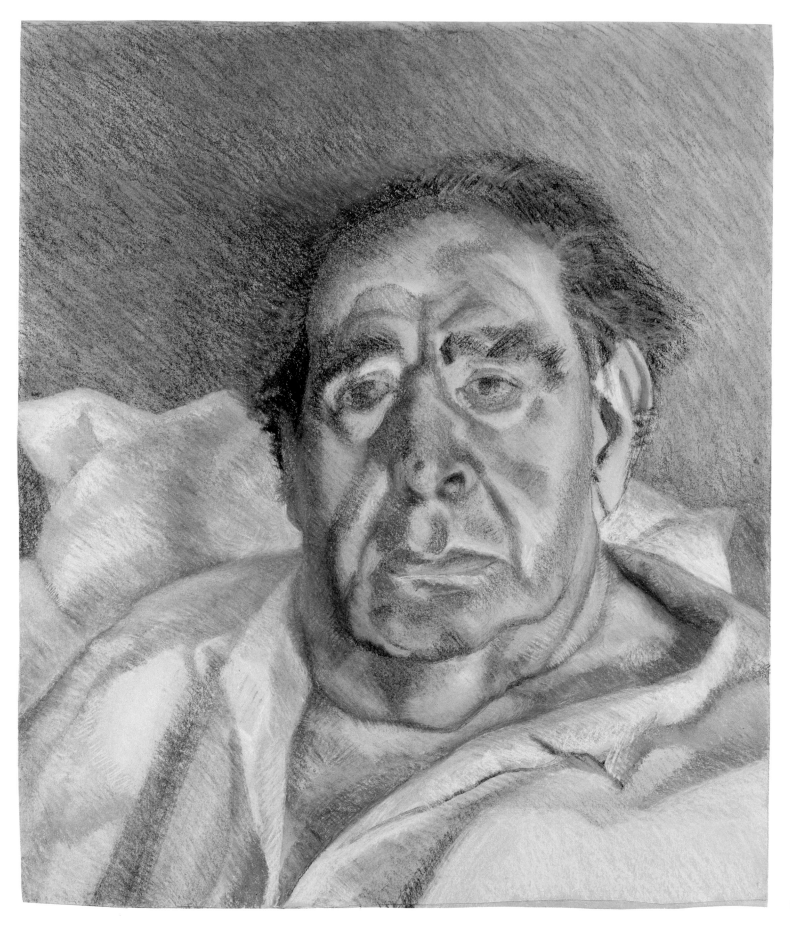

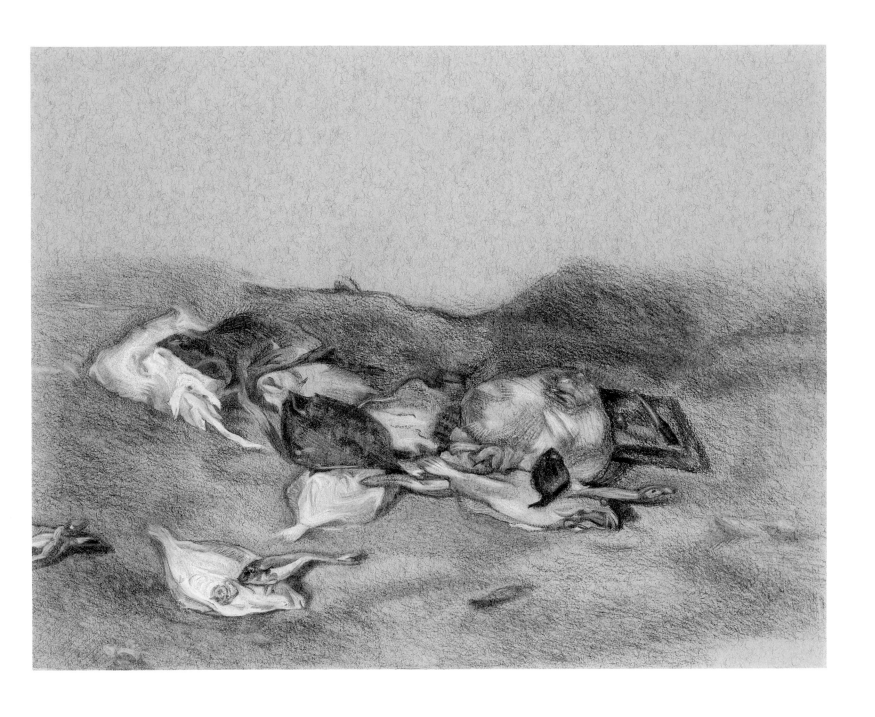

Prints 1936–1987

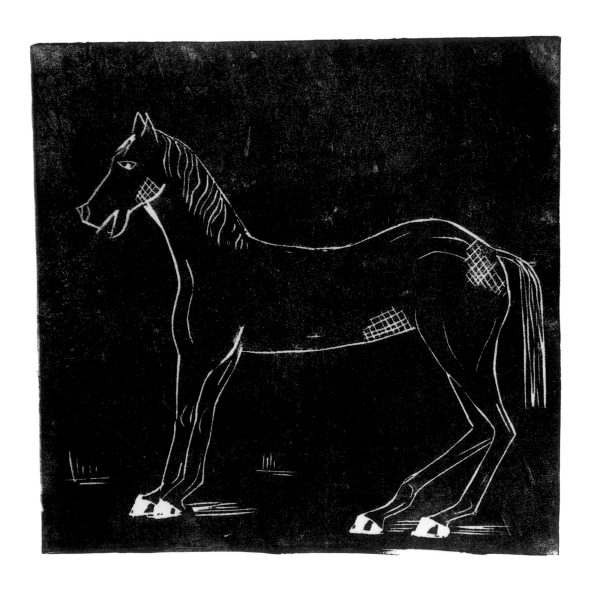

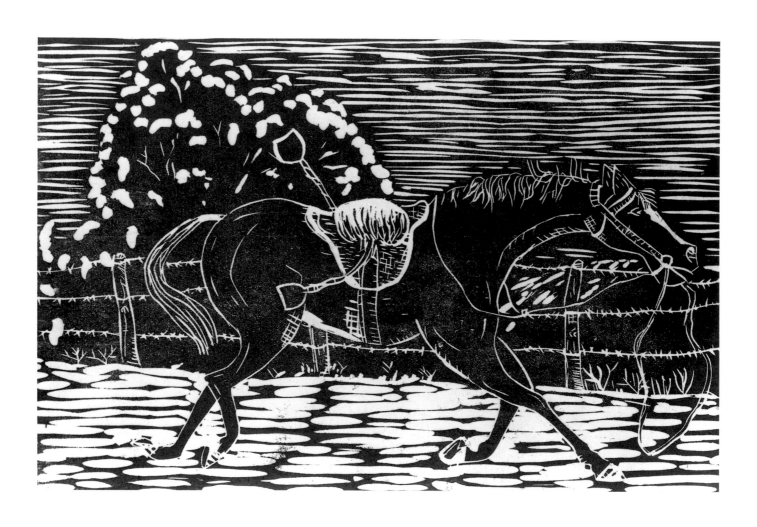

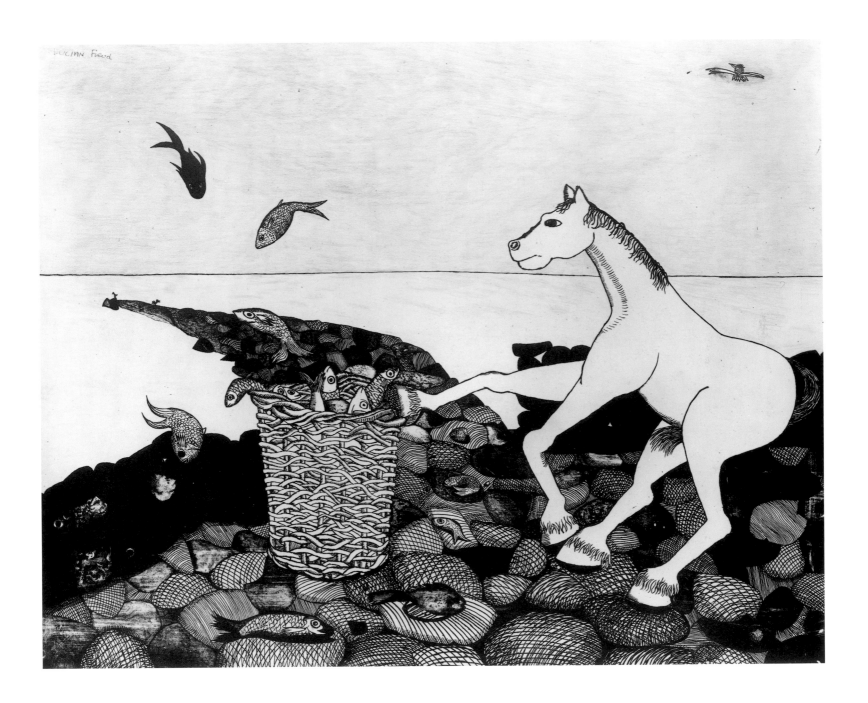

66

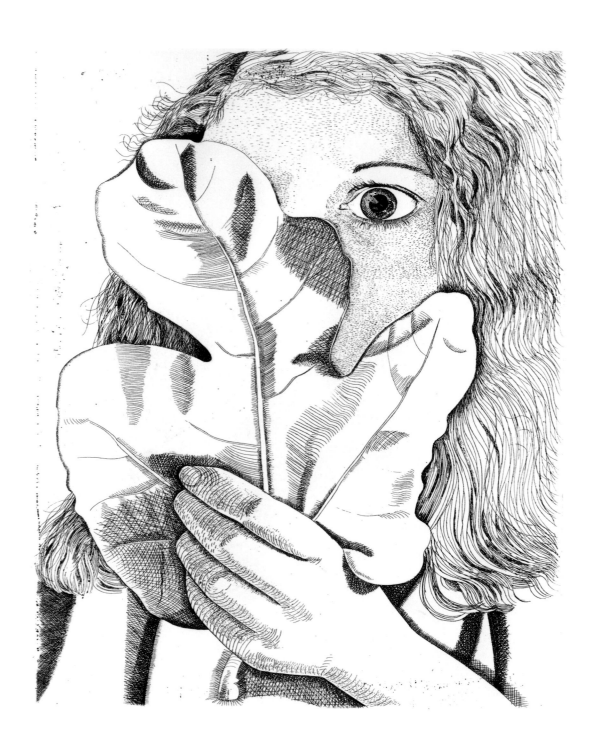

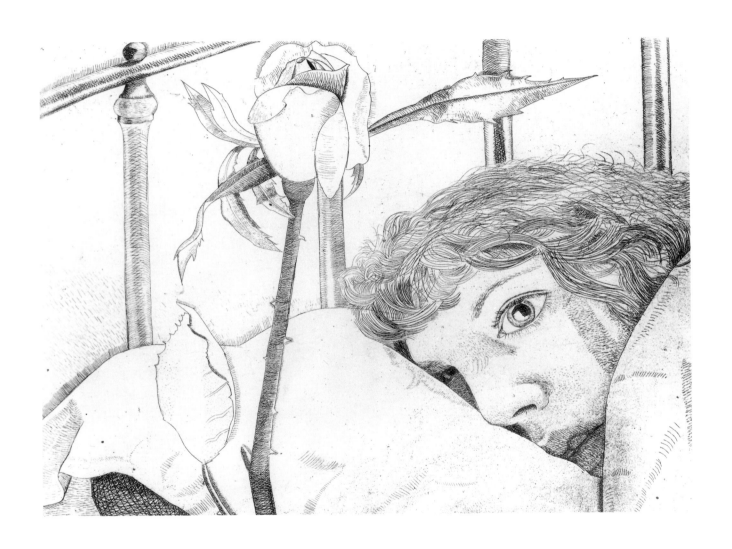

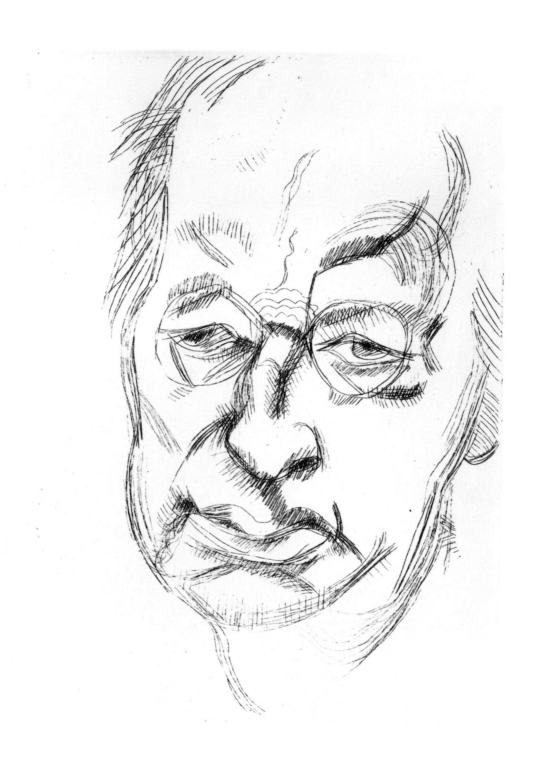

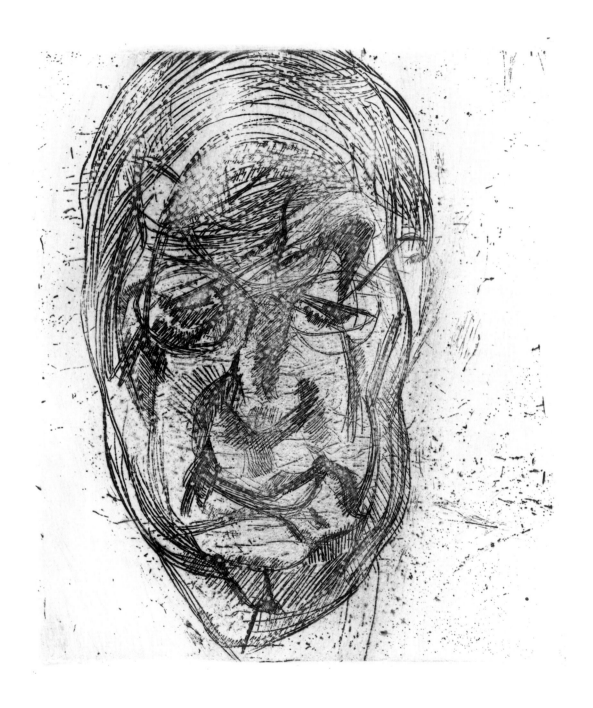

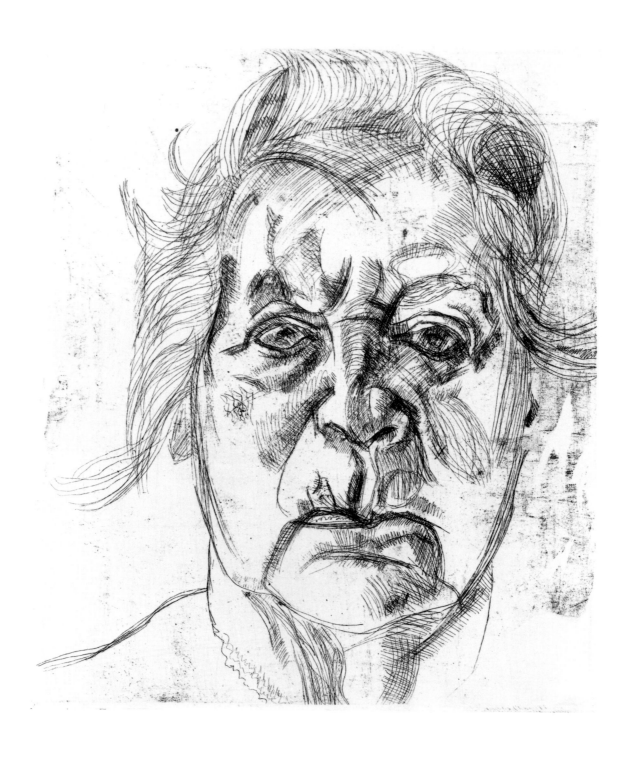

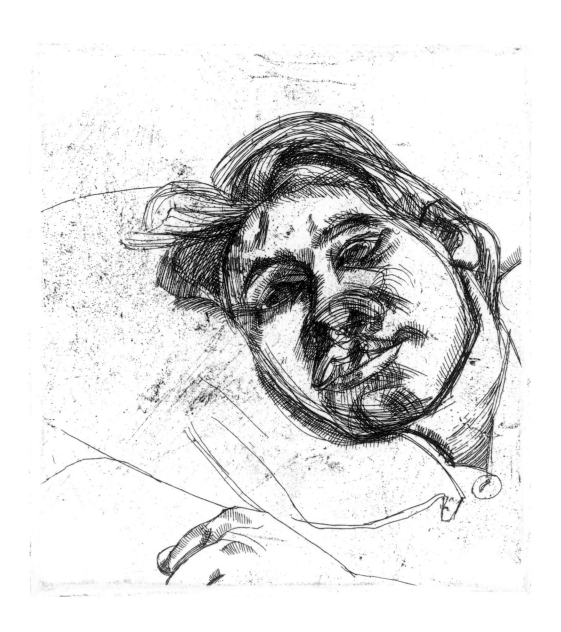

74

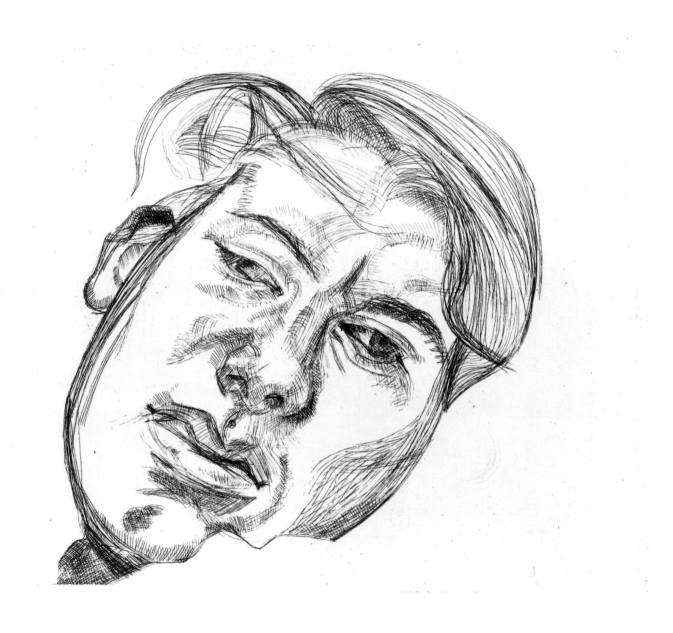

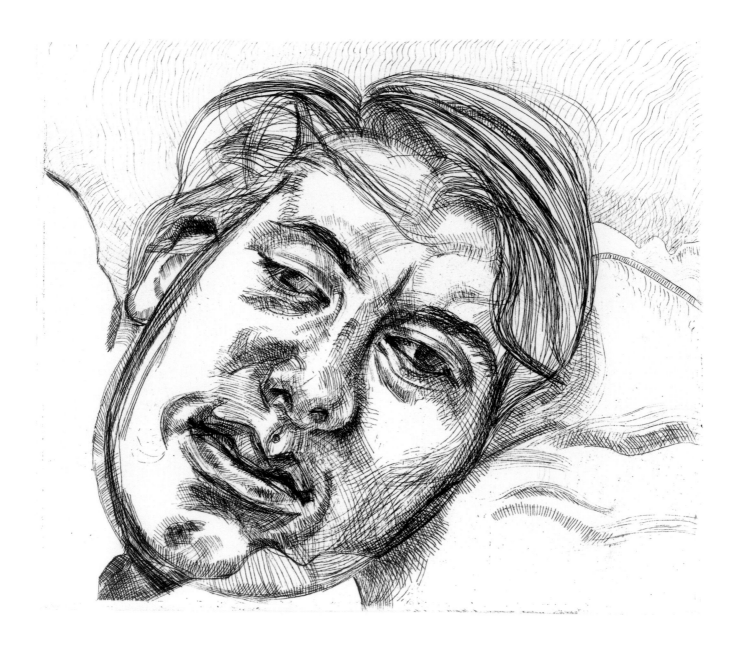

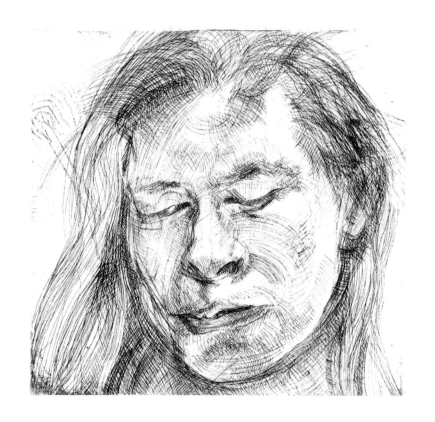

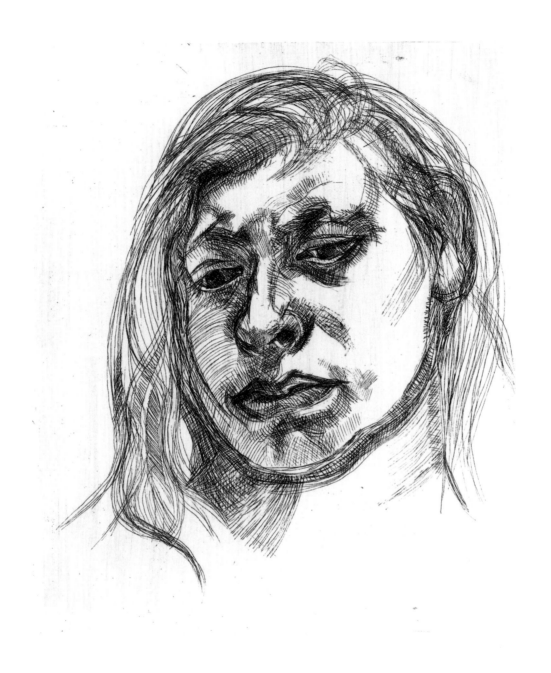

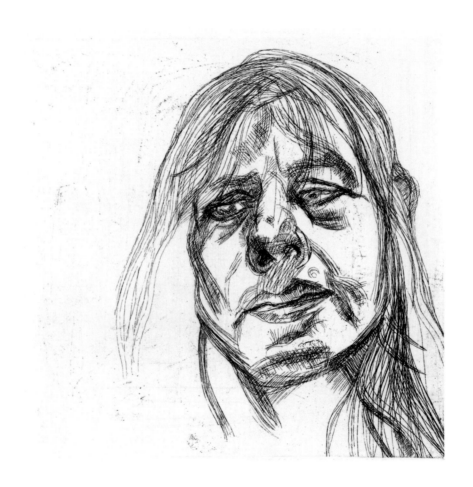

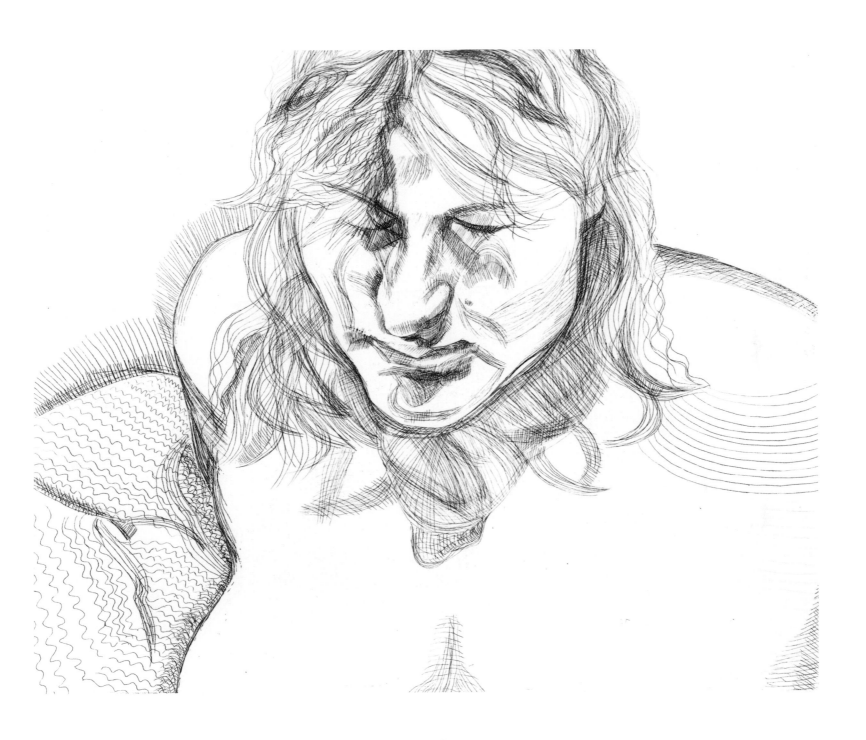

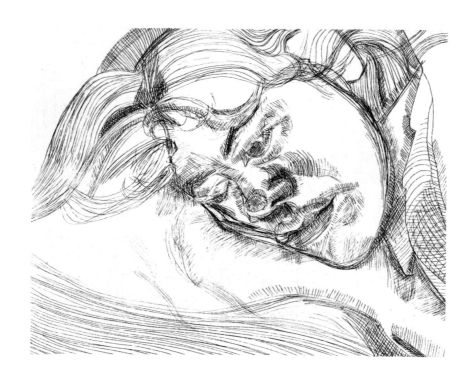

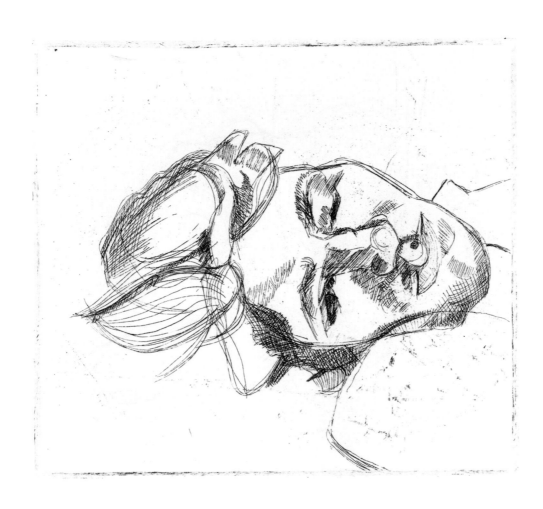

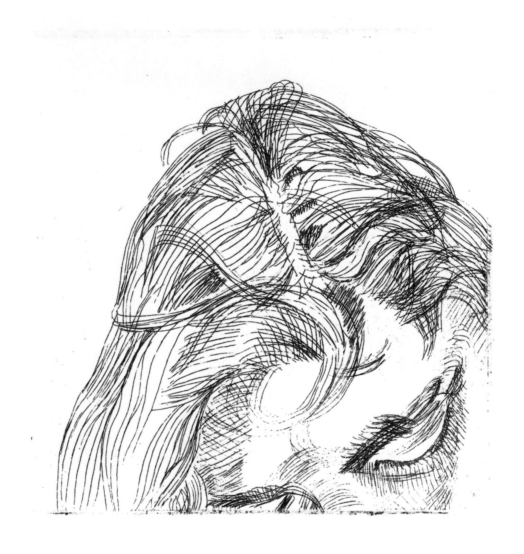

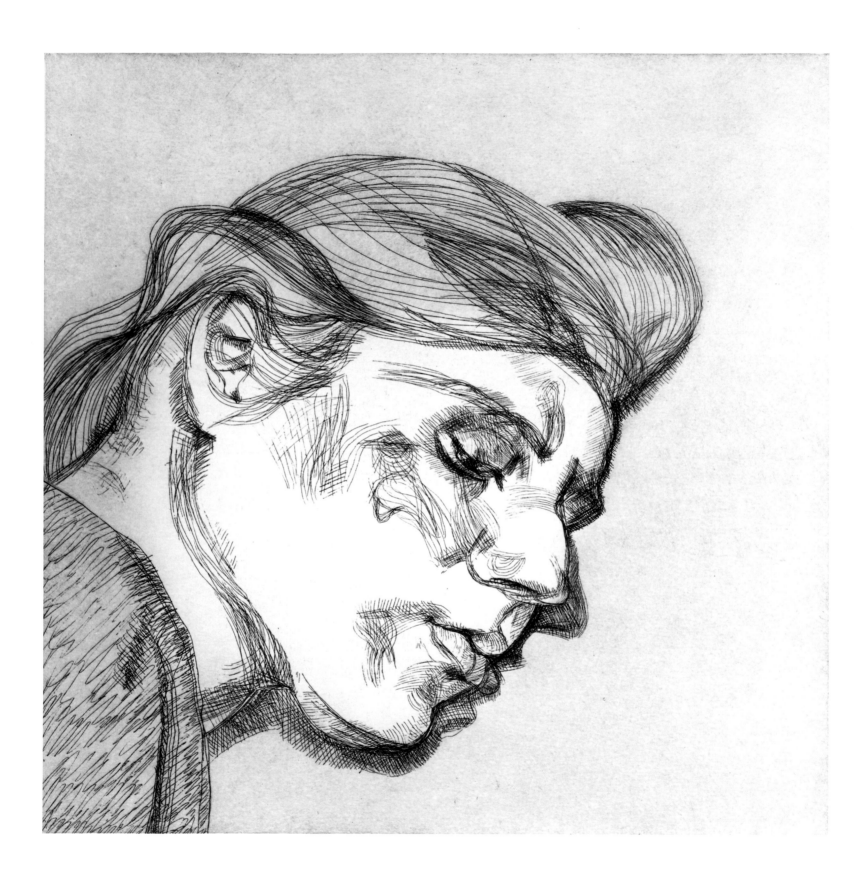

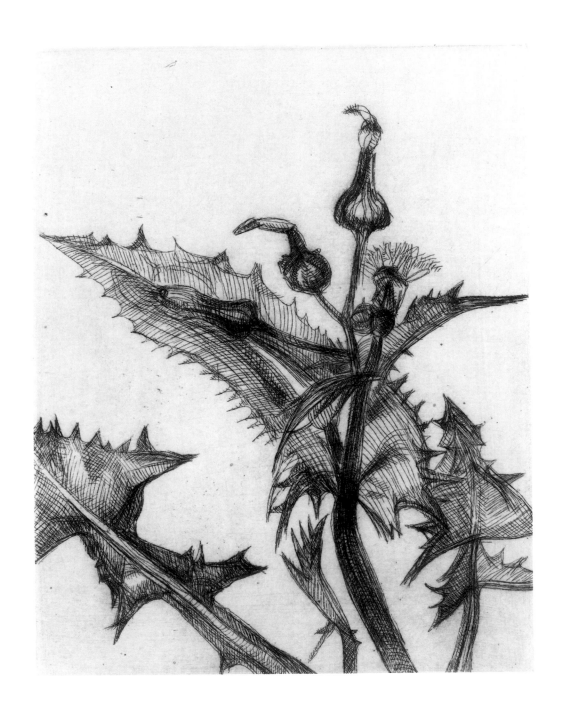

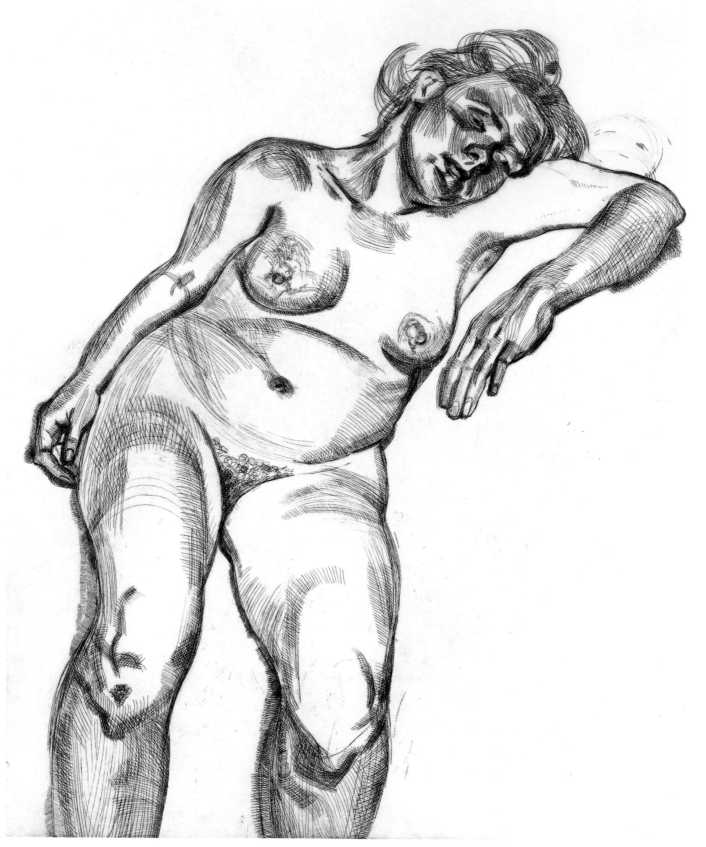

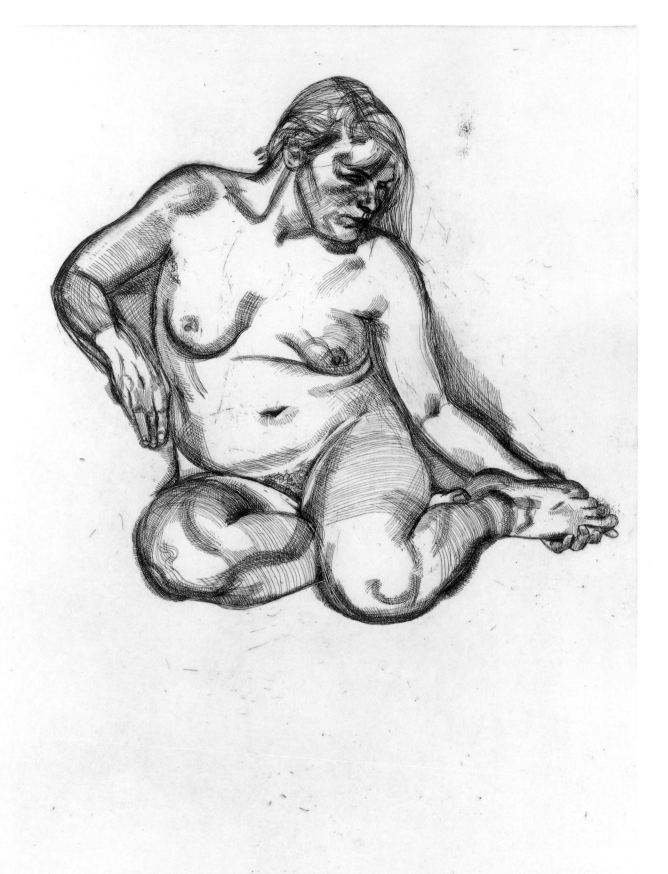

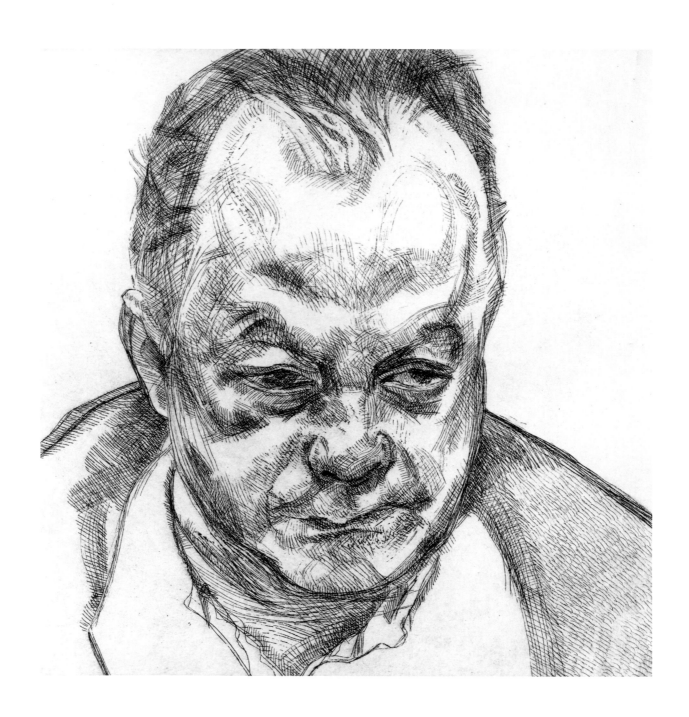

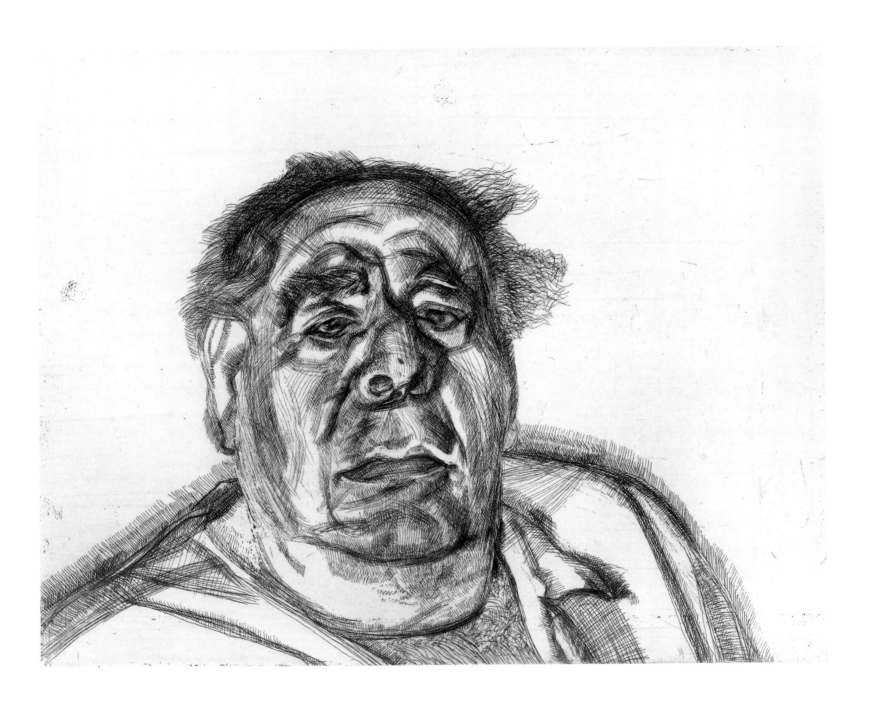

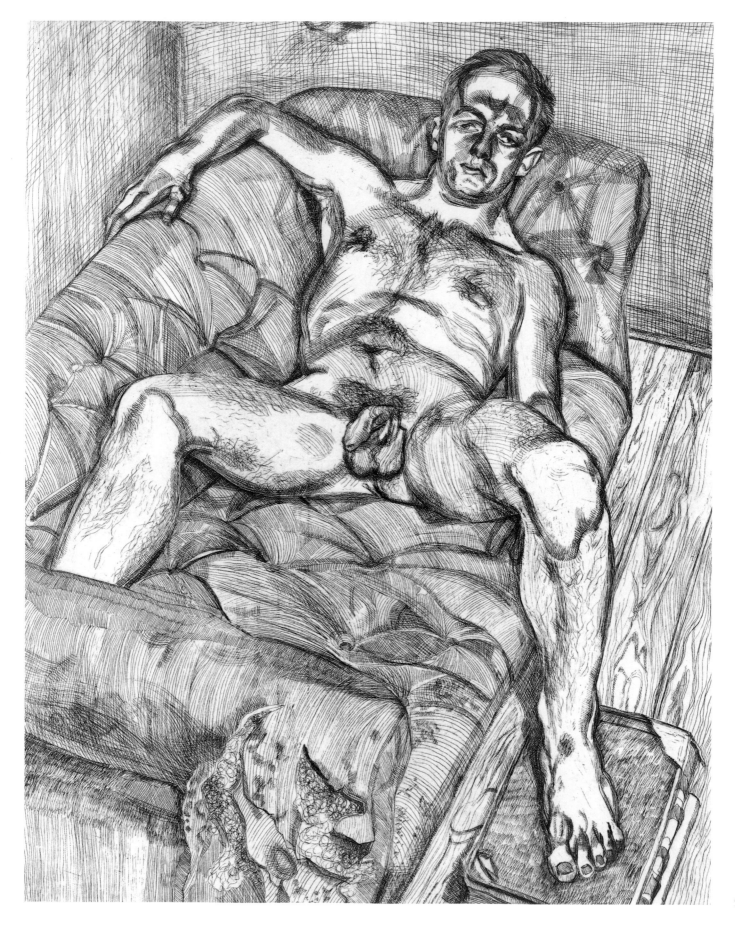

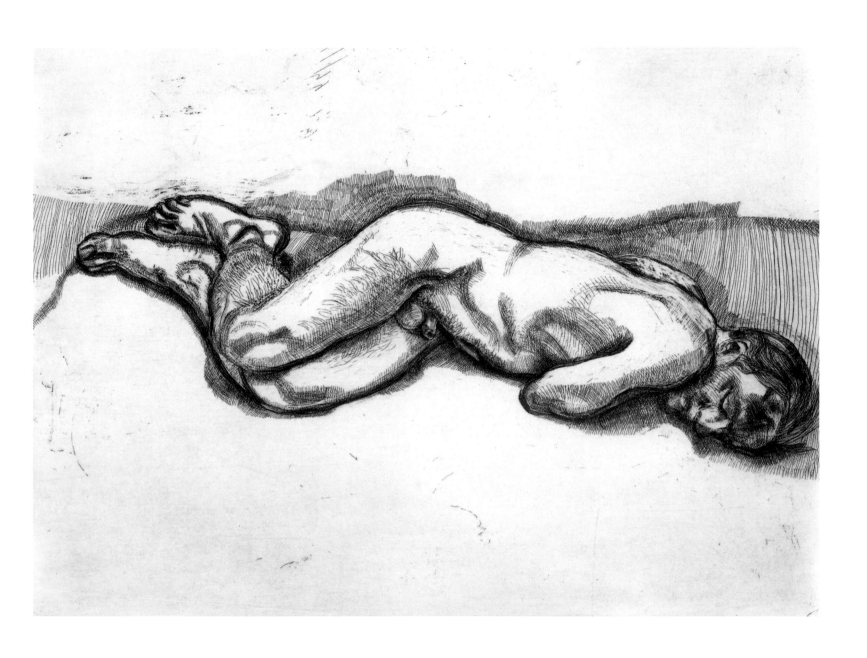

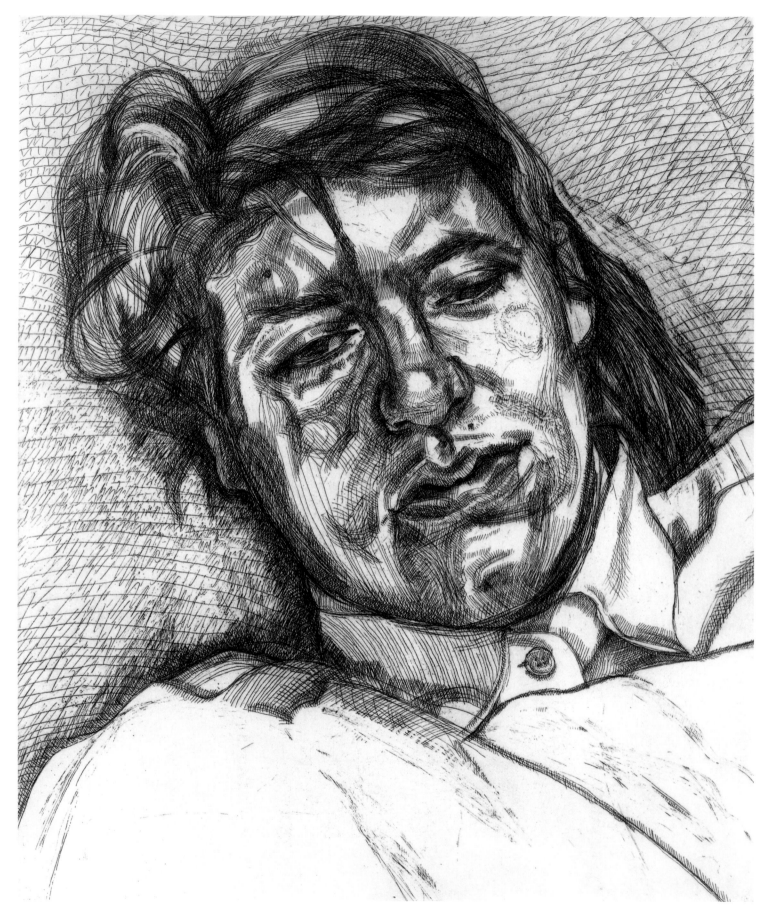

93

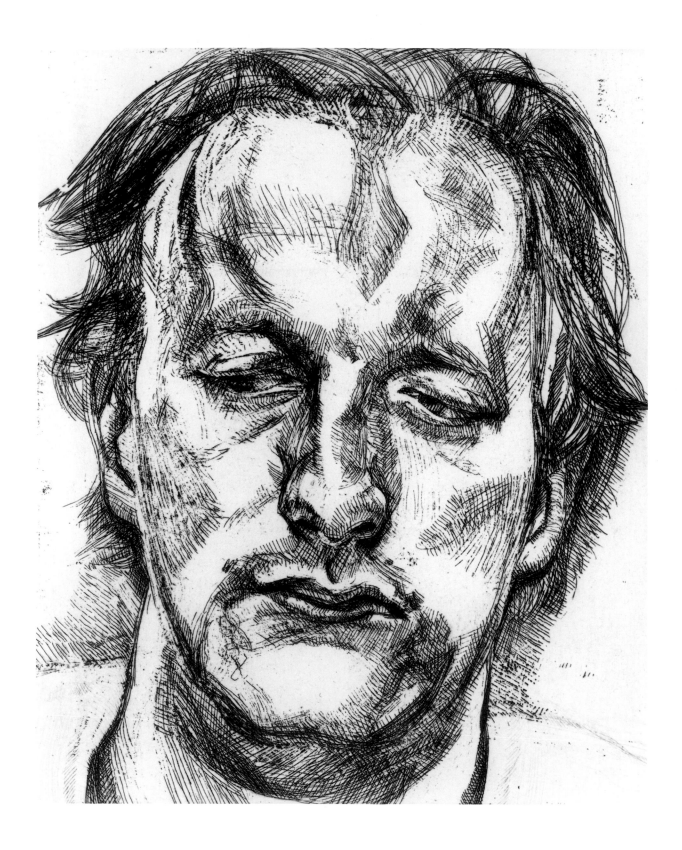

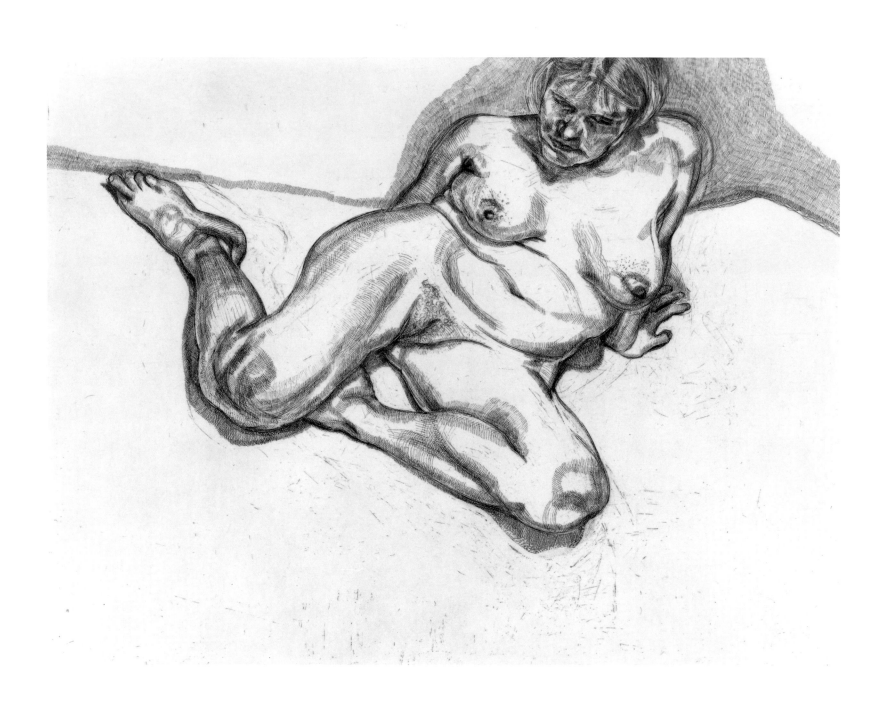

Lucian Freud

1922	Born December, in Berlin
1933	Came to Britain
1939	Naturalized British subject
1938/39	Studied at Central School of Arts and Crafts, London
1939/42	East Anglian School of Painting and Drawing, Dedham
1942/43	Part-time study at Goldsmiths' College, London
1946/47	Painted in Paris and Greece
1951	Arts Council Prize, Festival of Britain
1953/54	Visitor, Slade School of Fine Art, London
1983	Created a Companion of Honour
	Lives in London

List of Plates

frontispiece
Man in a leather coat, 1943
brush and ink
40.3 × 33 cm
Colin Self

1
In the silo tower, 1940
brush, pen and ink,
watercolour and varnish
20.5 × 32.4 cm
James Kirkman Ltd., London

2
Able Seaman, 1941
ink and oil paint
37.2 × 24.1 cm
Thomas Gibson Fine Art Ltd., London

3
Naval gunner, 1941
pen and ink
23 × 19.7 cm
Private collection

4
David Gascoyne, 1942
pen and ink on yellow paper
12 × 18 cm
Private collection, courtesy Anthony d'Offay
Gallery, London

5
Boy with a pipe, 1943
pencil
40 × 32 cm
Mr and Mrs Michael M. Thomas

6
Boy in bed with fruit, 1943
pen and ink
33 × 22.3 cm
Private collection

7
Boy on a bed, 1943
pen and ink
36 × 24 cm
Private collection

8
Juliet Moore asleep, 1943
black and white conté pencil on grey paper
34 × 46.3 cm
Private collection

9
Cacti and stuffed bird, 1943
pencil and blue crayon
41 × 53.3 cm
James Kirkman, London

10
Dead bird, 1943
ink, watercolour and gouache
36.9 × 52.1 cm
James Kirkman Ltd., London

11
Loch Ness from Drumnadrochit, 1943
pen and ink
39.7 × 45.4 cm
Private collection

12
Head of a woman, 1943
black and white conté pencil on brown Ingres
paper
47.3 × 30.1 cm
Private collection

13
Self-portrait, 1943
conté pencil and coloured crayons
44.4 × 26 cm
Mr and Mrs William Govett

14
Head of a man, 1943/44
black and white conté pencil on buff paper
34.3 × 28 cm
Collection of Carter Burden

15
Chicken in a bucket, 1944
mixed media
38 × 39.5 cm
Private collection

16
Rotted puffin, 1944
conté pencil and coloured crayon
20.7 × 14.6 cm
James Kirkman, London

17
Gorse sprig, 1944
conté pencil and crayon on Ingres paper
45.8 × 30.5 cm
James Kirkman, London

18
Scotch thistle, 1944
conté pencil and crayon
22.9 × 33 cm
Private collection

19
Sea holly, 1944
pen and ink, coloured wash and crayon
42.5 × 50.8 cm
Private collection

20
Man with folded hands, 1944
conté pencil heightened with chalk on buff
paper
29.5 × 45 cm
The Duke of Devonshire

21
Boy on a balcony, 1944
conté pencil and coloured crayon on buff paper
53.5 × 35.5 cm
Private collection

22
Boy with a pigeon, 1944
black and white conté pencil and coloured
crayon on grey paper
50 × 33 cm
Private collection

23
Girl holding her head, 1944
conté pencil and coloured crayon
11.4 × 17.9 cm
James Kirkman, London

24
Landscape with Scillonian pine, 1945
conté pencil and coloured chalk on grey paper
45.7 × 47.6 cm
Trustees of the Cecil Higgins Art Gallery,
Bedford

25
Castor oil plant, 1946
pen and ink
50.2 × 37 cm
Private collection

26
Drawing from Flyda, 1947
pen and ink
12.7 × 13.9 cm
Private collection

27
Man at night (self-portrait), 1947/48
pen and ink
51.5 × 42.5 cm
Private collection

28
Christian Bérard, 1948
black and white conté pencil on buff Ingres
paper
41 × 44 cm
Private collection
(Not in exhibition)

29
Mother and baby, 1949
pen and ink on brown paper
19 × 12 cm
Annie Cornet

30
Dead monkey, 1950
pastel
21.2 × 36.2 cm
The Museum of Modern Art, New York,
Gift of Lincoln Kirstein

31
Interior scene, 1950
pastel
48.2 × 57.1 cm
Private collection

32
Girl's head, 1954
pencil
34.3 × 25.4 cm
Private collection

33
Girl resting, 1961
watercolour and pencil
24.2 × 33.6 cm
Private collection

34
Head of a child, II, 1961
watercolour and pencil
34.2 × 24.7 cm
R. B. Kitaj

35
Annie reading, 1961
watercolour and pencil
34.2 × 24.1 cm
Private collection

36
I miss you, 1968
pen and ink
33.7 × 24.1 cm
Private collection

37
A filly, 1969
mixed media
34.5 × 24 cm
Private collection

38
Francis Bacon, c. 1970
pencil
33 × 23.8 cm
Private collection

39
Girl on a bed, 1974
purple ink
24.1 × 17 cm
Joy Emery Gallery, Michigan

40
The painter's father, 1970
pencil
22.9 × 16.5 cm
Private collection

41
The painter's father, 1970
watercolour and pencil
24.2 × 33.6 cm
Private collection

42
Head of a girl, 1973
pencil
25 × 20 cm
Mr and Mrs John Garland Bowes

43
Drawing for naked figure, 1973
brush and ink
55.8 × 45.1 cm
James Kirkman, London

44
Alice, 1974
pencil
19.3 × 24.4 cm
Arts Council of Great Britain

45
Annabel, 1975
pencil and watercolour
24 × 19 cm
Collection Matthew Marks, New York

46
Head and shoulders of a girl, 1977
pencil
19.6 × 24.7 cm
Private collection, courtesy Anthony d'Offay
Gallery, London

47
Two fragments, 1977
brush and sepia ink
each 33.7 × 24.7 cm
Private collection

48
Girl with a monkey, 1978
charcoal
35.9 × 52 cm
Mr and Mrs Bryan G. Kleckner

49
Head and shoulders of a girl, 1979
charcoal
32.5 × 24.1 cm
Trustees of the British Museum

50
Man with head wounds, 1981
charcoal and crayon
33 × 25 cm
Private collection

51
Head of Success, 1983
charcoal heightened with white crayon on buff
paper
24.1 × 33.7 cm
James Kirkman Ltd., London

52
Ib, 1983
charcoal and pastel
29.8 × 38.1 cm
Claus Runkel Fine Art Ltd., London

53
Head of Ib, 1983
charcoal
33 × 49.5 cm
Private collection

54
*Four heads from 'Large interior, W.11 (after
Watteau)'*, 1983
brush, charcoal, turpentine
57.2 × 76.2 cm
Private collection

55
*Two figures from 'Large interior, W.11 (after
Watteau)'*, 1983
charcoal, turpentine and white crayon
76.2 × 56.5 cm
Collection Matthew Marks, New York

56
*Woman with geranium from 'Large interior, W.11
(after Watteau)'*, 1983
charcoal, turpentine and pastel
36.2 × 33.7 cm
Private collection

57
The painter's mother in bed, 1983
charcoal
24.2 × 33.2 cm
The Achenbach Foundation for Graphic Arts,
The Fine Arts Museums of San Francisco

58
The painter's mother, 1983
charcoal and pastel on buff paper
32.4 × 24.8 cm
Private collection

59
The painter's mother, 1984
charcoal, white crayon and pastel
32.4 × 24.7 cm
Dr and Mrs Robert A. Johnson

60
Head of a man, 1986
charcoal
64.8 × 47.6 cm
The Museum of Modern Art, New York.
Gift of Agnes Gund

61
Lord Goodman, 1985
charcoal
64.2 × 47.8 cm
James Kirkman, London

62
Lord Goodman, 1986/87
pastel and charcoal
65.5 × 55.5 cm
Lord Goodman

63
Drawing after Turner, 1987
charcoal and white chalk on grey paper
31.7 × 40 cm
Private collection

64
Standing Horse, 1936
linocut
14.5 × 15 cm
Private collection

65
Runaway Horse, 1936
linocut
19.7 × 29.8 cm
The Duke of Devonshire

66
Horse on a beach, 1944
lithograph and crayon
48.2 × 42 cm

67
The bird, 1946
etching (edition of 3)
10.5 × 14.9 cm
Private collection

68
Chelsea bun, 1946
etching (proposed edition of 4, one proof
printed)
5.9 × 8.8 cm

69
Girl with fig leaf, 1947
etching (edition of 10) 9/10
29 × 23.5 cm

70
Ill in Paris, 1948
etching (edition of 10)
12.7 × 17 cm

71
Lawrence Gowing, 1982
etching (edition of 2)
17.5 × 12.8 cm

72
Lawrence Gowing, 1982
etching (edition of 25)
17.5 × 15 cm

73
The painter's mother, 1982
etching (edition of 25)
17.8 × 15.2 cm

74
Bella, 1982
etching (edition of 25)
14.5 × 13.3 cm

75
Bella, (first state) 1982
etching (unpublished)
15.2 × 17.8 cm

76
Bella, (second state) 1982
etching (unpublished)
15.2 × 17.8 cm

77
Head of a girl, I, 1982
etching (edition of 16)
11.2 × 11.5 cm

78
Head of a girl, II, 1982
etching (edition of 16)
16.2 × 13 cm

79
Head of a woman, 1982
etching (edition of 25)
12.7 × 12.7 cm

80
Head and shoulders, 1982
etching (edition of 20)
24.5 × 30 cm

81
Head on a pillow, 1982
etching (edition of 14)
10.2 × 12.7 cm

82
Small head, 1982
etching (unpublished)
11.4 × 12.7 cm

83
Fragment head, 1982
etching (unpublished)
12.5 × 12.3 cm

84
A couple, 1982
etching (edition of 25)
11.5 × 11.5 cm

85
Ib, 1984
etching (edition of 50)
29.3 × 29.4 cm

86
Thistle, 1985
etching (edition of 30)
17 × 13.5 cm

87
Blond girl, 1985
etching (edition of 50)
69 × 54.2 cm

88
Girl holding her foot, 1985
etching (edition of 50)
69 × 54 cm

89
Head of Bruce Bernard, 1985
etching (edition of 50)
29.3 × 29.5 cm

90
Lord Goodman in his yellow pyjamas, 1987
etching and watercolour (edition of 50)
31.1 × 40.3 cm

91
Man posing, 1985
etching (edition of 50)
70 × 55 cm

92
Naked man on a bed, 1987
etching (unpublished)
36.9 × 52.1 cm

93
Bella, 1987
etching (edition of 50)
42.2 × 34.8 cm

94
Head of a man, 1987
etching (edition of 20)
22.6 × 18.3 cm

95
Girl sitting, 1987
etching (edition of 50)
53 × 70.5 cm

*All etchings courtesy James Kirkman Ltd., London;
Brooke Alexander, New York, unless otherwise
stated*

Selected Exhibitions	1944	Lefevre Gallery, London (with Felix Kelly and Julian Trevelyan)
	1946	Lefevre Gallery, London (with Ben Nicholson, Graham Sutherland, Francis Bacon, Robert Colquhoun, John Craxton, Robert MacBryde and Julian Trevelyan)
	1947	The London Gallery (with John Craxton)
	1948	The London Gallery (with James Glesson, Robert Kippel, John Pemberton, Cawthra Mulock)
		Galerie René Drouin, Paris
	1950	Hanover Gallery, London (with Roger Vieillard)
	1952	Hanover Gallery, London (with Martin Froy)
		Vancouver Art Gallery
	1954	British Pavilion XXVIII Venice Biennale (with Ben Nicholson and Francis Bacon)
	1958	Marlborough Fine Art, London
	1963	Marlborough Fine Art, London
	1968	Marlborough Fine Art, London
	1972	Anthony d'Offay, London
	1974	Retrospective exhibition, Hayward Gallery (Arts Council of Great Britain) and tour
		'Pages from a sketchbook of 1941', Anthony d'Offay, London
	1978	Anthony d'Offay, London
	1979	Davis & Long Co, New York
		Nishimura Gallery, Tokyo
	1982	Anthony d'Offay, London
	1983	Thomas Agnew & Sons, London
		Bernard Jacobson, New York
	1987/88	Retrospective exhibition, organized by the British Council: Hirshhorn Museum and Sculpture Garden, Smithsonian Institution, Washington, D.C.; Musée National d'Art Moderne, Paris; Hayward Gallery, South Bank Centre, London; Neue Nationalgalerie, Berlin

Selected Group Exhibitions	1942	New Year Exhibition, Leicester Galleries, London
		'Imaginative Art since the War', Leicester Galleries
	1948	'Forty Years of Modern Art', Institute of Contemporary Art, London
	1950	'London–Paris', Institute of Contemporary Art
	1951	'Sixty Paintings for '51', Arts Council, London
		'British Painting 1925/50', Arts Council
	1952	'Recent Trends in Realist Painting', Institute of Contemporary Art
	1953	'Portraits by Contemporary British Artists', Marlborough Fine Art, London
	1955	'Daily Express Young Artists' Exhibition', New Burlington Galleries, London
	1962	'British Self Portraits from Sickert to the Present Day', Arts Council
	1963	'British Painting in the Sixties', Tate Gallery, London
	1966	'British Painting since 1945', Tate Gallery
	1967	'English Paintings 1951–1967', Norwich Castle Museum
		'Recent British Painting from the Peter Stuyvesant Collection', Tate Gallery
	1976	'The Human Clay', Arts Council of Great Britain, Hayward Gallery
		'Real Life: Peter Moores Liverpool Project 4', Walker Art Gallery, Liverpool
	1977	'British Painting 1952–1977', Royal Academy of Arts, London
	1979	'Treasures from Chatsworth: The Devonshire Inheritance', Royal Academy of Arts
		'The British Art Show', Arts Council of Great Britain touring exhibition
	1981	'Eight Figurative Artists', Yale Center for British Art, New Haven
		'A New Spirit in Painting', Royal Academy
	1984	'The Hard Won Image', Tate Gallery
		'As of Now', Peter Moores Liverpool Project 7, Walker Art Gallery
	1984/85	'The Proper Study', The British Council: Lalit Kala Akademi, Delhi; Jehangir Nicholson Museum of Modern Art, Bombay

1985	'The British Show', Art Gallery of New South Wales, Sydney, in association with The British Council
	'A Singular Vision', Royal Albert Memorial Museum, Exeter, and tour
1986	'Forty Years of Modern Art,' Tate Gallery
1987	'British Art in the 20th Century', Royal Academy of Arts
1987/88	'A School of London: Six Figurative Painters', Kunstnernes Hus, Oslo; Museum of Modern Art, Louisiana; Museo d'Arte Moderna, Ca'Pesaro, Venice; Kunstmuseum, Düsseldorf

Bibliography

Selected Catalogue Essays and Monographs

John Russell, *Lucian Freud*, catalogue introduction to exhibition at the Hayward Gallery, Arts Council of Great Britain, 1974
John Rothenstein, *Modern English Painters*, Macdonald, London, 1974
Lawrence Gowing, *Lucian Freud*, Thames and Hudson, London, 1982 (paperback 1984)
Robert Hughes, *Lucian Freud Paintings*, 2 editions (with 95 illustrations and with 112 illustrations), British Council, both also Thames and Hudson, London and New York, 1987 and 1988

Selected Articles

Lucian Freud, 'Some Thoughts on Painting', *Encounter*, July 1954
Bernard Denvir, 'Masterpieces Explained', *The Artist*, June 1955
David Sylvester, 'Portrait of the Artist', *Art News and Review*, 17 June 1955
John Russell, 'Lucian Freud – Clairvoyeur', *Art in America*, vol. 59, January 1971
John Russell, 'Sights of London', *The Sunday Times*, 15 October 1972
William Feaver, 'New Realists', *London Magazine*, vol. 12, pt. 6, February/March 1973
Paul Overy, 'Lucian Freud's Visual Autobiography', *The Times*, 29 January 1974
Robert Melville, 'Brief Spell', *New Statesman*, 1 February 1974
William Feaver, 'Lucian Freud – The Analytical Eye', *Sunday Times Magazine*, 3 February 1974
Michael Shepherd, 'Faces of Freud', *The Sunday Telegraph*, 3 February 1974
Marina Vaizey, 'Lucian Freud', *The Financial Times*, 14 February 1974
Lynda Morris, 'Freud's Images', *The Listener*, 2 March 1978
John McEwen, 'No More Sugar-Coating', *The Spectator*, 16 October 1982
Marina Vaizey, 'When the Subject Matters', *The Sunday Times*, 17 October 1982
William Packer, 'The Best Painter in this Country', *The Financial Times*, 19 October 1982
Jeffrey Bernard, 'A Star for Me', *The Times*, 23 October 1982
Christopher Neve, 'Night Pictures: A Scrutiny', *Country Life*, October 1982
Timothy Hyman, review, *Artscribe*, no. 38, December 1982
E. B. Henning, 'New Paintings by Four Artists from Britain', *Bulletin of the Cleveland Art Museum*, vol. 69, pt. 10, December 1982
Michael Peppiatt, 'Lucian Freud', *Art International*, vol. XXVI, pt. 1, January 1983
Jonathan Keates, 'Lucian Freud', *Harpers and Queen*, October 1983
Marina Vaizey, 'The Rebirth of Painting', *Life*, September 1986
William Feaver, 'A Reasonable Definition of Love', *Architectural Digest*, July 1987
Robert Hughes, 'On Lucian Freud', *New York Review of Books*, 13 August 1987
John Russell, 'A Painter's Insights Into Body and Soul', *New York Times*, 29 September 1987
Jean Clair, 'Lucian Freud: Restoring the Paint-Flesh Ritual', *Art International*, autumn 1987
Sanda Miller, 'People by Lucian Freud', *Artforum*, October 1987

Photographic credits

A C Cooper Ltd, London
Prudence Cuming Associates, London
Tom Scott, Edinburgh
Rodney Todd-White, London
The Cecil Higgins Art Gallery, Bedford